IMAGES
of America

IRISH
SAN FRANCISCO

IMAGES
of America

IRISH
SAN FRANCISCO

John Garvey and Karen Hanning

ARCADIA
PUBLISHING

Published by Arcadia Publishing
Charleston SC, Chicago IL, Portsmouth NH, San Francisco CA

Printed in the United States of America

Library of Congress Catalog Card Number: 2007941647

For all general information contact Arcadia Publishing at:
Telephone 843-853-2070
Fax 843-853-0044
E-mail sales@arcadiapublishing.com
For customer service and orders:
Toll-Free 1-888-313-2665

Visit us on the Internet at www.arcadiapublishing.com

To John Joseph Garvey, my grandfather, who left the farm in Galway for
Boston in 1908 and ventured to California. His father, Patrick, signed
his name "X"; John's sons graduated from UC Berkeley and one became
an otolaryngologist. Grampa stressed while other things could be lost,
education could never be taken away.

—John Garvey

Special credit goes to my grandparents, John and Anne Mitchell, for
remembering and answering those questions I asked when I had the
opportunity. Now there are so many more I would ask; we all realize that
too late. If you still have elders, talk to them now, and record
their answers.

—Karen Hanning

CONTENTS

ACKNOWLEDGMENTS

Thank you first to the many wonderful people who generously contributed their personal photographs, ephemera collections, and rich stories. Of all the many others, we want to mention the following: San Francisco United Irish Cultural Center Library volunteers Maureen Kelleher Lennon and Joan Riordan Menini, who helped us navigate though what is considered the best Irish library west of the Mississippi and its 3,000 titles; Diarmuid Philpott, San Francisco Police Department deputy chief (retired) and board member of the Irish Cultural Center; Dr. William Lipsky, for his information about the 1898 Irish Fair; all Arcadia Publishing staff, especially Katie Kellett and CEO Richard Joseph; Peter Fairfield at GAMMA labs for his outstanding photographic expertise; Francis Kelly the publican at Ireland's 32 for his encouragement; educator Raymond L. John, Ed.D.; Fr. Joseph Walsh, St. Stephen's Church; Fr. Tom Parenti, St. Brendan the Navigator Church; San Francisco's Zoo Station for their fantastic U2 sounds; all San Francisco Main Public Library History Center staff, especially photograph curator Christina Loretta and director Susan Goldstein; Bernie "Topgold" Goldbach in Kilkenny, Ireland, who is assisting the authors with the planned literary tour for this book in Ireland; the memory of San Francisco 49ers coach Bill Walsh and his motivational talk to John; Kyoko, Christopher, and Sean Garvey, for their great patience while this project was being developed into a book; most importantly, for the prayers from the members of Notre Dame des Victoires of San Francisco and the Japanese Christian Church of Walnut Creek while John beat malignant melanoma skin cancer on his ear, and while Karen was the primary caregiver for her friend Diana, who died of mesothelioma. Life has given both of the authors major challenges in the finalization of this project, but with our prayer and effort, the outstanding people at Arcadia Publishing have helped to make this important project a reality that you can now enjoy.

INTRODUCTION

Obviously there are more comprehensive histories of the Irish in San Francisco, but we hope our version will pleasantly augment these as a sort of broad family album of both pioneer and later-arriving Irish inhabitants of the city by the bay. Some of our subjects are people who came directly from the Emerald Isle; others are native San Franciscans whose ancestry is in part Irish. Still others are those of Irish descent who first came from other places in our country, such as Boston or New York, but made San Francisco their ultimate home.

We have included an assortment of different neighborhoods and classes to show the broad range of influence the Irish had on the development of the city and the Bay Area in general. It is sometimes argued that there are more Irish in the San Francisco Bay Area than anywhere else in the world, including Boston and New York. Regardless of the validity of that statement, one important distinction is that the Irish were part of San Francisco's development from the very beginning. In San Francisco, natives of the Emerald Isle were free to exert much more extensive influence in the founding and furthering of the city than in either of the aforementioned cities or in any area of the eastern United States in general. In the West, and especially in San Francisco, the Irish were among the first to arrive and put forth effort to create new homes and businesses relatively free from the constraints, restrictions, and prejudices they and other newcomers often labored under in the more settled parts of the country.

Here the Irish were a major force from the start, and the city grew up with the input and influence of the Irish as a matter of course. The Irish were free to seek advancement and education as soon as they could grasp the possibilities and opportunities that abounded in the days of the Gold Rush and beyond. As a result, the San Francisco Irish are a different breed than those in eastern-influenced areas. This is true for many other pioneer groups and ethnicities in the West. They came here from all over the world and learned that the race could be entered, and maybe won, by anyone who could run. This book presents Irish who came during the Gold Rush up to those who have arrived in more recent times.

By just walking through the streets of San Francisco, one is reminded of the Irish heritage. A few examples include Hayes, O'Shaughnessy, McCoppin, Phelan, and Downey Streets. The Irish are responsible for many of the great buildings of the city, such as the Flood and Phelan buildings and the Fairmont Hotel. By 1859, the Irish had a banking institution of their own, the Hibernia Bank, whose headquarters, built in 1892, is one of the most beautiful structures in the city. The property, situated at 1 Jones Street, is San Francisco Landmark No. 131. Many Irish who struck it rich in the gold fields or in the Comstock Nevada silver lode reinvested their money in the city in land and businesses. Three of the four "Silver Kings" were born in Dublin, and all lived in San Francisco at least part-time. Between 1850 and 1882, the California Militia had the Meagher Guard, called the "Irish Invincibles," in San Francisco.

Many others who did not go after gold or silver participated in farming, dairying, stock raising, and many other sorts of business, including public works and engineering projects. By 1870, San Francisco's population of 100,000 was one-third Irish, and one in every three Irish men owned

real estate. The Irish were prominent early in the political sphere. David Broderick arrived in San Francisco after having been frustrated in attempts to join political circles in New York. He was elected state senator in 1849 and, in 1851, became president of the senate. John Geary, the first non-Hispanic mayor, was elected *alcalde* in 1850 and in 1867. Frank McCoppin, of County Longford, was another of 14 Irish or at least half-Irish-descended mayors. Tom Hayes, of Roscarberry, County Cork, was the initiator of the first transport in the city, the railroad from Market Street to Mission Dolores, and owned the land currently occupied by the civic center. Peter Donahue was a prominent engineer; Michael Morris O'Shaughnessy was responsible for Yosemite's Hetch Hetchy project and dam, which has supplied the highest quality city water in the nation to San Francisco since 1923.

San Francisco is rich in Irish people and supporters. Belva Cottier, a Sioux woman with Irish blood, was part of the movement to have American Indians reclaim Alcatraz Island from the federal government in 1964 and 1969. Belva's grandfather was a red-headed Irishman in the U.S. Army's 7th Calvary. Novelist Alice Walker, who lives in the Alamo Square area, has some Irish lineage. African American mayor Willie Brown made columnist Herb Caen's column when the mayor led a boycott of an Irish whiskey maker by dumping a Bushmill's 100-percent malted barley down a San Francisco gutter in protest of what he perceived to be unfair labor practices in Ireland. U2's Bono even spray painted in jest the Vaillancourt Fountain during a free concert at Justin Herman Plaza. Johnny Foley's Irish House at 243 O'Farrell Street and Jim and Artie Mitchell's emporium of eroticism known as Mitchell Brothers Theatre, located at 859 O'Farrell Street, are well-visited establishments. The city even showed its Irish side with a now-defunct hockey team in the 1980s, the San Francisco Shamrocks.

The city also boasts the *Irish Herald*, a free monthly newspaper started in 1962 by founder John Whooley, and at the New College of California at 766 Valencia Street in the Mission District, students may earn a bachelor's and a master's degree in Irish studies. The *San Francisco Chronicle* stated, "The Irish Studies Program at New College has established itself as one of the most innovative programs of its kind in the nation." The college also offers free public workshops such as "Green Roots: Irish American Family History," where instructors David Cassidy and Margaret McPeake "teach people how to research their Irish and Irish American family history through creative use of historical and genealogical methodologies, including census reports, government records, church records, ship logs, local history libraries and centers, and family oral history."

These are just a few of the faces, places, and organizations readers will encounter in this book. There are also many images of ordinary people at home in their neighborhoods, taking part in celebrations, family gatherings, and other activities, as well as images illustrating public life, work, and amusement. Naturally, limited space prevents us from including everything and leaves no room for many things we wanted to include. You will, however, see much that is familiar and, we hope, a few things that are not. All will give you a wide sampling of the life the Irish and their descendants have been able to make for themselves in this region.

One

1845–1900

One of the original native daughters of the Golden West, Kate Maloney was born in San Francisco in 1862 and poses here in the fashionable garb of the 1880s. Her nephew Peter Maloney founded the humorously named South of Market Boys, a group of fun-loving prominent men who were instrumental in benevolent and administrative functions, as well as numerous social events often mentioned by columnist Herb Caen in the early to mid-1900s. (Courtesy Ginny Maloney family.)

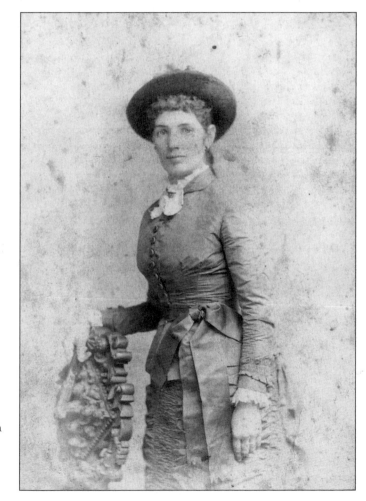

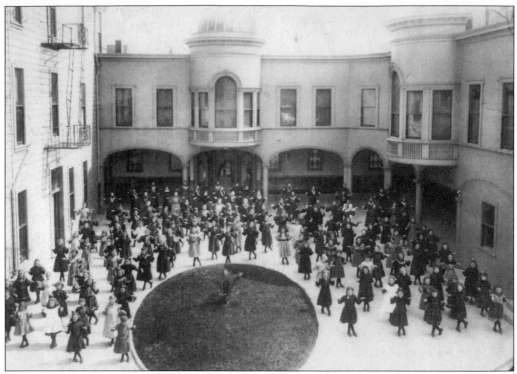

These girls, pictured in 1890, attended Immaculate Conception Academy, one of the first girls' schools in San Francisco to provide a complete education for women from grammar through high school. Irish dance was a part of every child's education throughout the country at this time, evidence that only more recently did this type of dancing begin to be considered a specifically ethnic activity. (Courtesy Immaculate Conception Academy.)

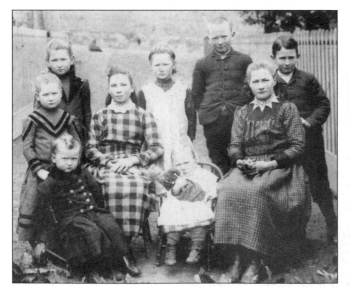

Margaret Mitchell was widowed when her youngest of eight was only two months old. The boy standing at far right is Margaret Mitchell's sister's son who had recently moved to San Francisco from his birthplace, a large ranch near Tombstone, Arizona. He became an early pioneer priest, Fr. Laurence O'Keefe, S.J. The others pictured here all remained in San Francisco; only four were married with children. (Courtesy Edward Mitchell family.)

Jasper O'Farrell, an Irish engineer from Dublin, landed by ship in the Yerba Buena cove in 1843. When the *alcalde* of San Francisco decided that a detailed map of the town was needed to show existing streets and designate future ones, O'Farrell was chosen to map the city. San Francisco's Market Street is patterned after Market Street in Philadelphia, and O'Farrell Street was named after Jasper O'Farrell. (Courtesy San Francisco History Center, San Francisco Public Library.)

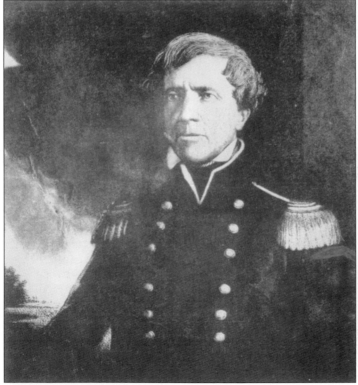

The family of Stephen Kearney, the military governor of California before statehood in 1847, emigrated from Ireland, where their name had been "O'Kearny." General Kearney was a career army officer who was known as the "father of the United States Cavalry." He is honored by a street in downtown San Francisco that was named for him. (Courtesy San Francisco History Center, San Francisco Public Library.)

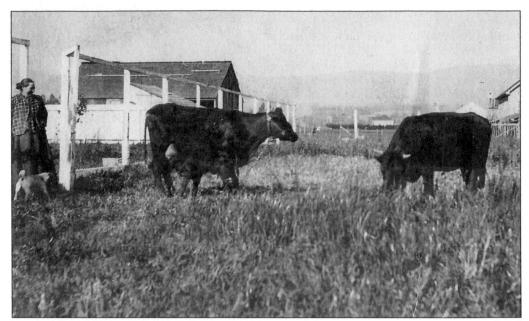

Many Irish in the southern areas of San Francisco had dairies—cows being both practical and a status symbol in the old country—but dairies that were limited in size because of insufficient land. This dairy was on what is currently Madrid Street. An elderly granddaughter of the original owners recalled how she loved to visit because she could "run through the fields and feel the wind blowing through [her] hair." (Courtesy Thomas Mitchell family.)

Peter Maloney's farm, south of San Francisco, is an example of another business that was familiar from the old sod but was often a successful endeavor in the city as well. Maloney's son Edward, desiring a more exciting life, joined the San Francisco police force but became one of the first killed in the line of duty after he struggled with a thief. Edward's 1915 funeral brought together all his fellow officers to pay tribute. (Courtesy Betty Garvey.)

James Flood was one of four men who controlled the bonanza mines of Nevada's Comstock Lode, the richest silver mines in history. Flood was born in New York City in 1826 and came to San Francisco in 1849. Once silver was discovered in 1859, Flood and William O'Brien began to speculate in mining stock with James Fair and John Mackay. The four of them formed the Consolidated Virginia Mining Company. (Courtesy San Francisco History Center, San Francisco Public Library.)

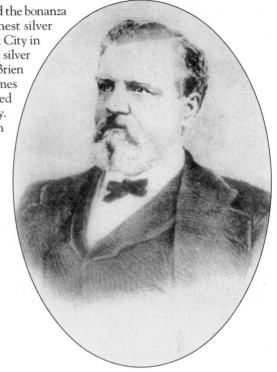

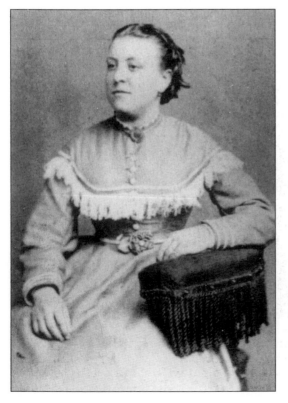

Jennie McComb must have been a very strong woman to have made her way to San Francisco from Erie, Pennsylvania, alone after her parents had gone "upstairs" (to heaven). McComb became quite well-to-do in California, and her new life was like that of many immigrants—full of opportunity to achieve their dreams and desires. (Courtesy Fulwider family.)

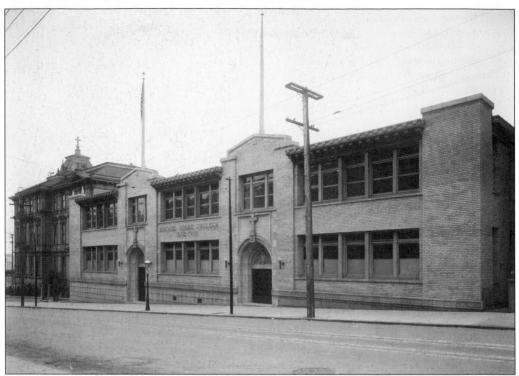

Founded in 1852, Sacred Heart Cathedral Preparatory (commonly abbreviated as SH, SHC, or SHCP) is the oldest Catholic secondary school in San Francisco. Located in the heart of the city on Cathedral Hill, SHCP became the first coed high school in San Francisco when Cathedral High School for girls merged with Sacred Heart High School for boys in 1987. (Courtesy San Francisco History Center, San Francisco Public Library.)

The well-known St. Patrick's Orphan Asylum on Market Street, now the site of Palace Hotel, and St. Patrick's Church were both destroyed in the 1906 earthquake and fire. Only the church was rebuilt. (Courtesy San Francisco History Center, San Francisco Public Library.)

John Downey, California's first foreign-born governor, was born in Roscommon, Ireland, in 1827. A druggist by profession, he followed the Gold Rush to California, prospected in Grass Valley, and was elected to the state assembly. As lieutenant governor, Downey vetoed the bulkhead bill, which would have allowed ownership of San Francisco's waterfront by a monopoly. (Courtesy San Francisco History Center, San Francisco Public Library.)

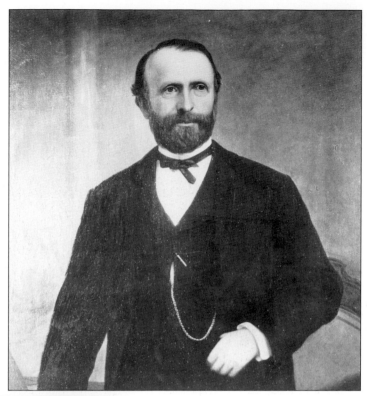

Born in 1834 in County Longford, Frank McCoppin became the first Irish-born mayor of San Francisco. He immigrated to America in 1853 and was made supervisor of the Market Street Railway, where he encouraged planting among the railroad tracks to control drifting sands. McCoppin Square, in the Parkside District of San Francisco, is named in his honor, as are McCoppin Street and Frank McCoppin Elementary. (Courtesy San Francisco History Center, San Francisco Public Library.)

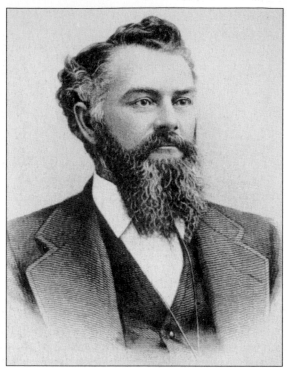

Born near Belfast, County Tyrone, in December 1831, James Graham Fair immigrated to America in 1843 and engaged in gold and silver mining. Later in life, he was elected as a Democrat from Nevada to the U.S. Senate in 1881 and served until 1887. He continued his real estate business from San Francisco and was buried at the city's Laurel Hill Cemetery in December 1894. (Courtesy San Francisco History Center, San Francisco Public Library.)

This is a very rare image of an early basketball team representing Sacred Heart Cathedral Preparatory. This educational institution, run by the Christian Brothers, prides itself on its commitment to its educational philosophy, as exemplified by the motto "Enter to learn; leave to serve." The school's colors are green, white, and blue. (Courtesy San Francisco History Center, San Francisco Public Library.)

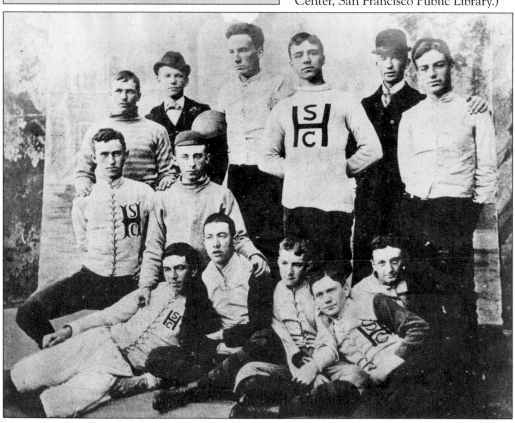

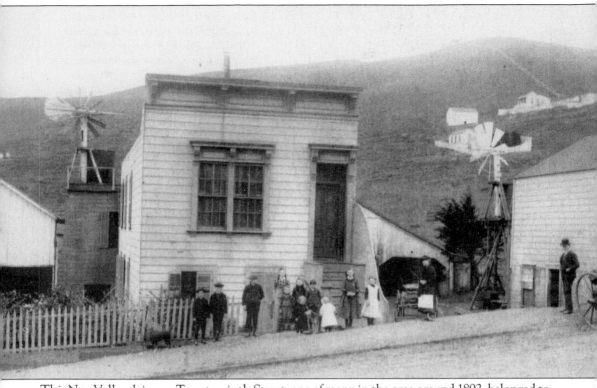

This Noe Valley dairy on Twenty-ninth Street, one of many in the area around 1892, belonged to the Mitchell family, whose father came from Knockroe, Killtulla, in County Galway. Two windmills on the property brought up ample water for both animals and people. Later Margaret Connors Mitchell, as a widowed mother of eight, made this water available to refugees who camped on the surrounding hills after the 1906 earthquake and fire. Higher on Red Rock Hill, to the left, is a former tannery, and to the right is the flue built for the Sun Valley Water Company. This area now accommodates Diamond Heights development, built in the 1960s. John Mitchell—the next-smallest boy in front of the family home and to the left of baby brother Ed, in white—is the future father of the brothers who would start the award-winning Mitchell's Ice Cream at 688 San Jose Avenue. (Courtesy Mitchell family.)

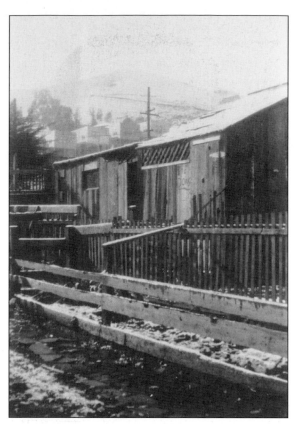

Dairy families, indeed everyone in Noe Valley in the mid-1800s to early 1900s, would easily recognize the farmyard where the cows ate and the usual outbuildings. This photograph was taken after the snow of 1909, a rare event in the Bay Area. (Courtesy Mitchell family.)

In these early views, Gold Mine Hill, below, and Red Rock Hill, left, were mostly grassland, providing grazing space for livestock. Where grubby farm kids once helped milk the cows, spotlessly clean babies wearing cute outfits are now rolled along the sidewalks in strollers. (Courtesy Mitchell family.)

James Phelan, a politician and banker, was born in 1861, the son of an Irish immigrant who became wealthy during the Gold Rush. Phelan graduated from St. Ignatius High School (often abbreviated as SI) in 1881, was elected mayor of San Francisco in 1897, and was elected to the U.S. Senate in 1915. He died at his Saratoga estate Villa Montalvo, now a state-run arts center, in 1921. Phelan Avenue is named after him. (Courtesy Robert Bowen.)

In the Irish community, a man's standing was judged by the number of bouquets at his funeral. Obviously John Maloney, keeper of a popular watering hole called the Cookoo's Nest, was a man of undoubted prominence. He lived in San Francisco but left behind six brothers to populate the peninsula. When a train conductor passed through the town of Menlo Park, he would often call out "Maloneyville" because of the large number of residents of that name in the community. (Courtesy Warren Maloney.)

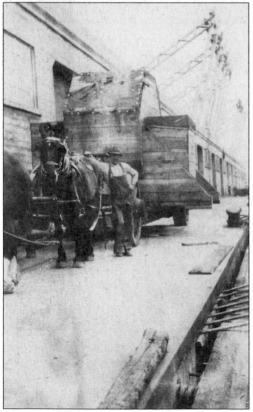

This photograph inside the office of early liquor importers was taken before 1898, since Leo, left, died that year. His father, Antoine, partnered with James Shea, listed in 1858 as living in the What Cheer House hostelry; they started the business in 1858. Though James died in 1902, the firm continued and had moved to 525 Market before it was destroyed in the first hour of a fire in 1906. Afterward, it moved to Mission until Prohibition ended the business. (Courtesy Gregory Zompolis.)

Unbeknownst to many San Franciscans, coal was once the favored fuel here, a fact testified to by the common "coal shoot driveways" throughout the city that steeply catapult one's car into the basement garage along the same route once taken by the sooty nuggets. These were burned in what are often assumed to be wood-burning fireplaces but whose shallowness attests to the fact they were actually constructed for coal. (Courtesy Barbara Hughes.)

Hibernia Bank, the first financial establishment in the city, was founded in 1879 by prominent businessman John Sullivan with 11 board members, whose descendants, the Tobins, managed the bank for four generations. Hibernia Bank's capital enabled the Irish to participate in many economic opportunities. The 1893 headquarters, arguably one of the city's most beautiful buildings, watches over the turning of each St. Patrick's Day Parade from Market Street into Civic Center. (Courtesy private collection.)

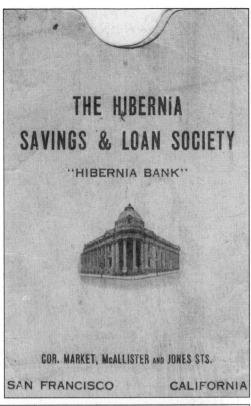

THE HIBERNIA SAVINGS & LOAN SOCIETY

"HIBERNIA BANK"

COR. MARKET, McALLISTER AND JONES STS.

SAN FRANCISCO CALIFORNIA

Shea-Boqueraz, a purveyor of "imported and wholesale liquors" at Front and Jackson Streets, is pictured here before the 1906 earthquake. The business was the West Coast's sole carrier of two then-famous brands of whiskey—Golden and Teacup—said to have "unexcelled reputations for purity and excellence." Shea-Boqueraz kept large stocks of these and many fine wines and cognacs, also imported, as California's wine production was then only small amounts for private use. (Courtesy Gregory Zompolis.)

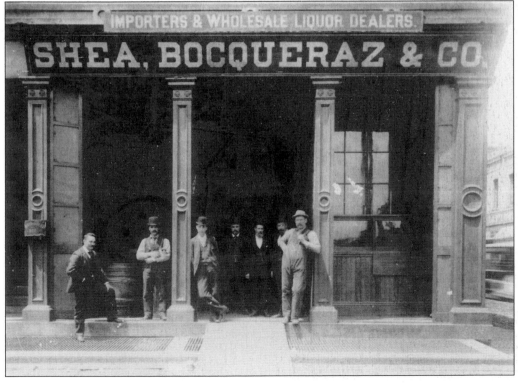

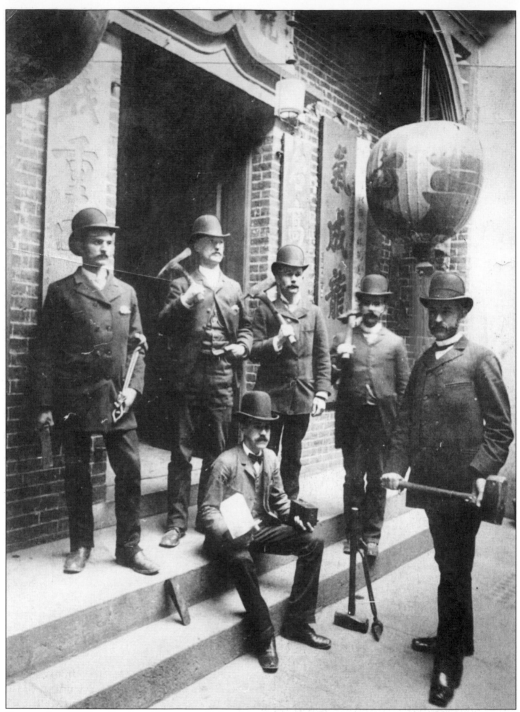

Pictured in 1889 is the San Francisco Police Department's Chinatown Vice Squad. The hatchets enabled the officers, many Irish American, to break into areas where opium was used and stored and other types of vice dens. The unit depicted here is made up of, from left to right, officers Jesse Cook, John Green, T. P. Andrews (seated), George Riordan, James Farrell, and George Whitman. The squad was later abolished as need for it diminished. (Courtesy City of San Francisco records.)

Electing a queen of the May began early in the city's history. Pictured here around 1882, Ella Shea, at age 16, serves in that capacity. Her outfit is adorned with hand-sewn seed pearls, and she has a white train, gauze veil, scepter, and flowers. Early queens were often of Irish descent. The tradition continues today but, naturally, with a much wider spectrum of ethnicity now represented. (Courtesy Gregory Zompolis.)

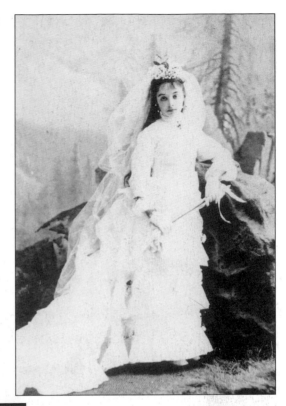

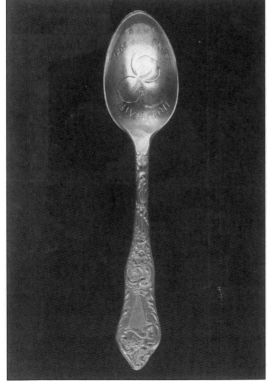

This silver spoon is a memento from the San Francisco Irish Fair, largely unknown to history. The fair took place at the Mechanics Pavilion August–September 1898 as a fundraiser for an Irish center. Note the harp on the top of the handle and shamrocks incorporated in the handle design and on the bowl. (Courtesy Peter Fairfield.)

The Maloney brothers and two cousins (Leslie Griffin, standing, fourth from left, and Jack O'Connor, standing, far right) are pictured around 1899 outside the saloon of the brothers' father, John, located at Third and Townsend Streets. Jack Maloney, at lower right, boxed in his early life and eventually retired from the California State Board of Equalization, which is concerned mainly with liquor licensing. (Courtesy Warren Maloney.)

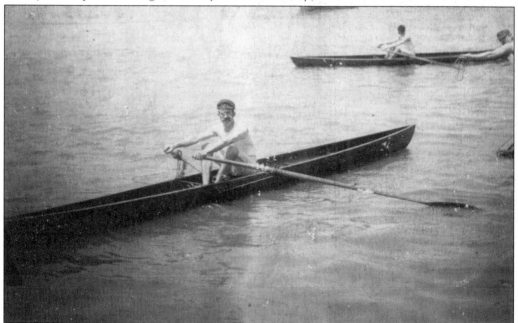

Rowing was a sport not ignored in the early days of the city. Here champion skiff master George Phelan appears at the ready for one such competition, with the slim boat's line held steady for the picture by a friend on shore. (Courtesy Hughes family.)

McKinney's Resort was a popular place to spend the day or a weekend in the late 1800s and early 1900s. One could take the ferry over for the day and spend a pleasant afternoon picnicking or "taking the air" in one of the rented buggies or on horseback. (Courtesy Edward Mitchell family.)

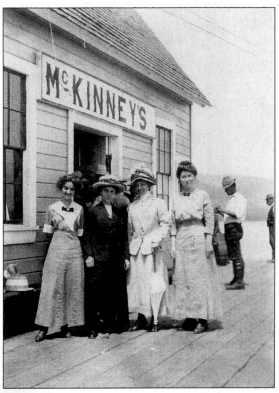

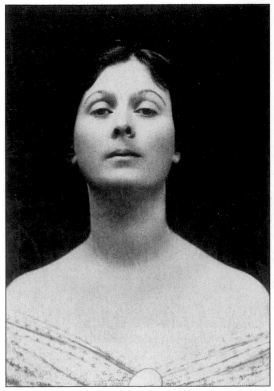

Isadora Duncan, born in San Francisco in 1877, became a well-known dancer and teacher but also became known for rebelling against the rules society placed on women and the laws governing marriage, divorce, property, and child custody. (Courtesy San Francisco History Center, San Francisco Public Library.)

Mary Desmond Chalmers came west with her husband, Patrick Chalmers, in a wagon train led by Kit Carson. In 1855, they settled on 250 acres in the Pajaro Valley, which they purchased from the original Spanish grantees, and raised strawberries. She became one of the premier businesswomen in the area and took over the ranch after her husband's death, living part-time, and then full-time in later years, in San Francisco with her son Dr. William P. Chalmers. (Courtesy Gregory Zompolis.)

As health inspector for the City of San Francisco, Dr. William P. Chalmers had his own tugboat and crew, which he used to inspect ships before they entered the bay. A rare agreement was struck with the tongs in Chinatown that Dr. Chalmers was not to be harmed and had access to all their territories. He was the only white man allowed in the area and is pictured here with one of his armed bodyguards. (Courtesy Gregory Zompolis.)

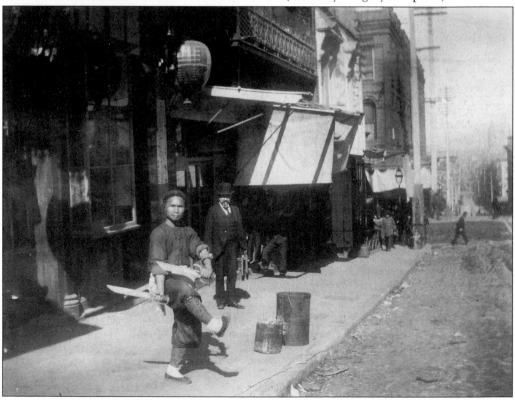

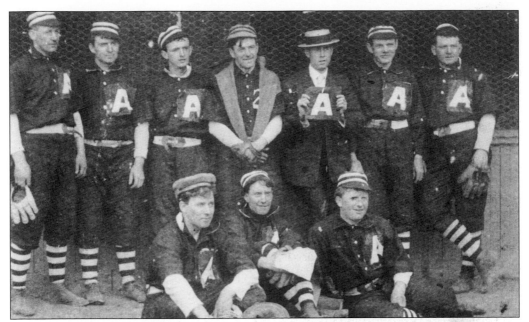

This early baseball team was one of many that took enthusiastic part in the national pastime in San Francisco. Several teams consisted mainly of Irish players, coaches, and sponsors. Today the Giants honor the region's Irish American community by holding "Irish Nights" at the ballpark, and Murphy's Pub in the park is named for Giants equipment manager Mike Murphy, who never missed a home game since 1958. (Courtesy Hughes family.)

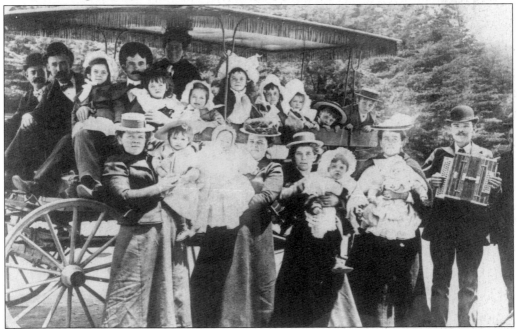

This happy party enjoys a holiday at McKinney's Resort. Many such popular picnic areas surrounded the city, providing a natural experience for those who crossed to Marin on the ferry or, later, took the train "down the Peninsula." Such equipages could be rented for an afternoon, just as automobiles are today. (Courtesy Hughes family.)

Many Irish women, like those pictured here in 1909, earned their livings in small shops or in the larger stores that had begun to come into fashion, such as City of Paris and the Emporium. Not all were called seamstresses, who were relatively unskilled workers. Beyond that, women could master pattern making and cutting and go on to earn the title of tailor, applied to both sexes capable of creating entire garments. (Courtesy Edward Mitchell family.)

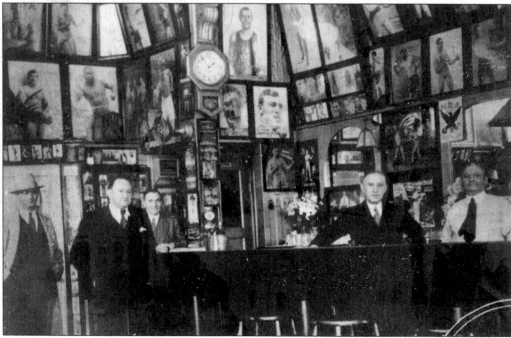

The Boxing Bar was the place for a gentleman to have a real night out with the boys. The place was one of the most exciting clubs around, and numerous well-known boxers and celebrities visited this establishment. Years later, when films became popular, silent boxing movies were shown nightly. (Courtesy Warren Maloney.)

Two

1900–1950

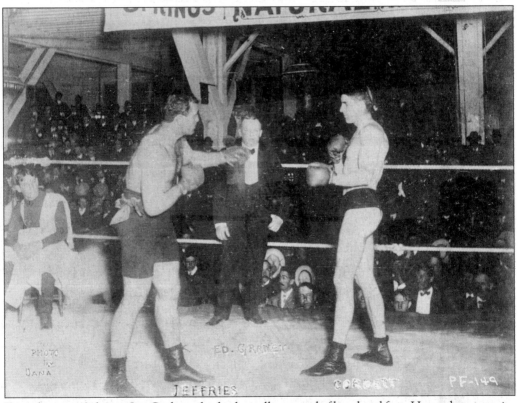

Fast, clever, and elusive, Jim Corbett also had excellent speed of hand and foot. He used a repertoire of jabs, hooks, and crosses while keeping his distance from his opponent. Corbett could stand within an arm's reach of his competitor and hit him without being struck himself. Some historians write that during his entire 18-year career, Corbett never received a black eye or bloody nose. (Courtesy San Francisco History Center, San Francisco Public Library.)

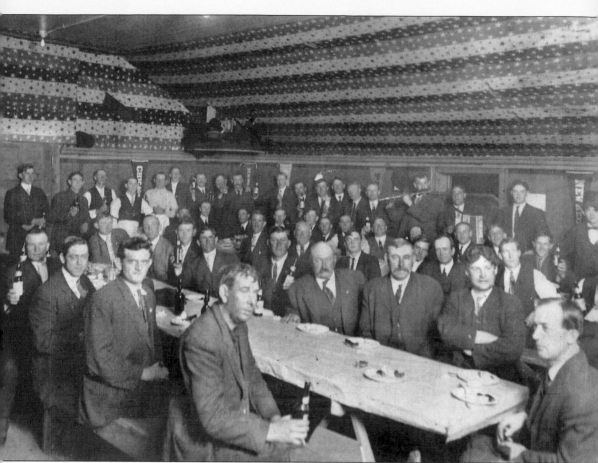

Pictured here is a gathering following a bare-knuckles boxing match, once a popular activity among Irish men who were enthusiastic devotees of the art of self-defense. It has been claimed that the bald man with the crooked tie, across the table and just to the right of center, was the well-known gunslinger Wyatt Earp, who in his later years lived in the Bay Area and was asked to judge various boxing matches. (Courtesy Mitchell family.)

A native of Galway, Fr. Peter Yorke arrived in San Francisco in 1888. In 1901, drayage companies escalated a minor quarrel over some conventioneers' luggage into a city-wide lockout of union labor. Yorke preached in the cause of the unions and threatened a boycott, and some give him credit for the collapse of the lockout only days later. A San Francisco street is named for Yorke. (Courtesy San Francisco History Center, San Francisco Public Library.)

In 1902, after her husband died, Julia O' Mahoney Kennedy came from Glengarrif, County Cork, with daughter Julia, who found work with William Alvords, a former San Francisco mayor and his wife. Mrs. Alvords often asked young Julie if she could use clothing that she no longer needed. Julie brought home an elegant black velvet cloak, which her mom wore with pride—the new land had indeed brought unprecedented opportunities. (Courtesy Sweeney family.)

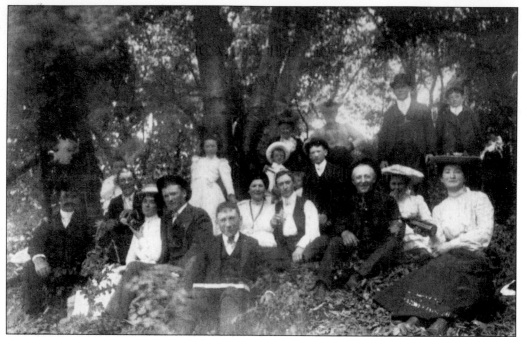

This picnic in the country was held to celebrate the end of the Spanish-American War. The lady standing in the background is most probably a Mrs. Scott, who was to lose her life, as did many, when bricks from her chimney crashed through her house during the 1906 earthquake in San Francisco. (Courtesy Mitchell family.)

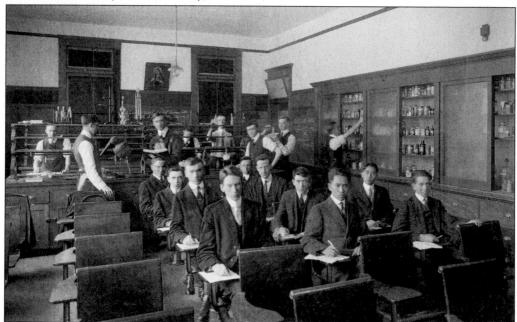

Pictured here is an early classroom at the well-appointed Sacred Heart instructional facilities. This Christian Brothers school's mascot is the "Fighting Irish," and the dress code at this time decreed a jacket and tie for all students. (Courtesy San Francisco History Center, San Francisco Public Library.)

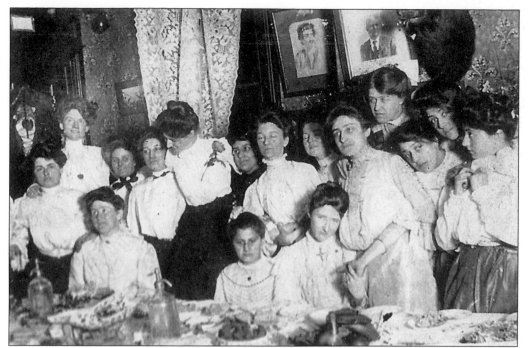

One of the many convivial community gatherings, according to newspaper clippings found in an old album, was the 18th birthday party of Emma Williams, who celebrated "by entertaining several of her friends in her home on Harrison Street." Enjoying the festivities, the article says, were several Heffernans, Downings, Murrays, Bradys, Mitchells, and Creyerses, with a Murphy and a Sullivan thrown in for good measure. (Courtesy Williams family.)

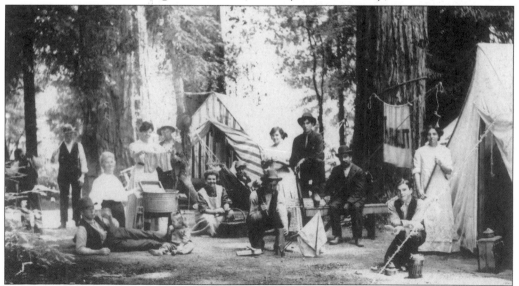

Camping was a popular activity in the early days, though done with somewhat more urban organization than today's campers would perhaps favor. Here various members and friends of the numerous Sullivan family of Arlington Street enjoy themselves at a campground in La Honda. Many Irish-descended San Francisco families acquired lots in this beautiful redwood area to the south, eventually building cabins there, most now permanent homes. (Courtesy Sullivan family.)

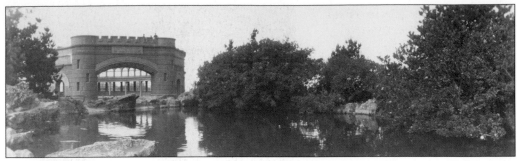

Thomas Sweeney, one of the wealthy landowners in the "Old Sand District," built a stone observatory in Golden Gate Park. The Sweeney Observatory capped Strawberry Hill from 1891 until 1906, when it collapsed during the earthquake. A two-story building, it resembled a small fortress on top of the hill and had commanding views of the city and the Golden Gate. (Courtesy San Francisco History Center, San Francisco Public Library.)

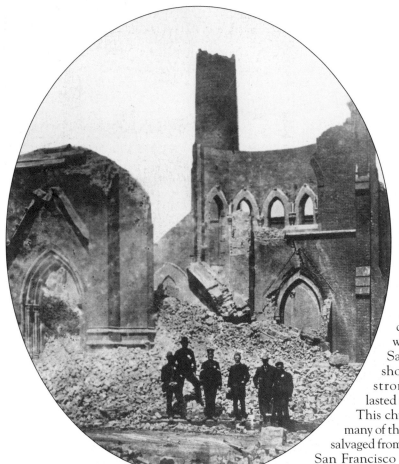

Pictured are the remains of St. Patrick's Church after the earthquake of April 18, 1906. At 5:12 a.m., the great quake broke loose with an epicenter near San Francisco. Violent shocks punctuated the strong shaking, which lasted some 45 to 60 seconds. This church was rebuilt using many of the same bricks that were salvaged from the rubble. (Courtesy San Francisco History Center, San Francisco Public Library.)

The strength of the Hibernia Bank Building allowed it to withstand the 1906 earthquake, but notice the area outside. People were forced to camp in the street or, at least, to cook there because of the fire danger. Luckily wood stoves could be taken apart and reassembled outside. (Courtesy Ginny Maloney.)

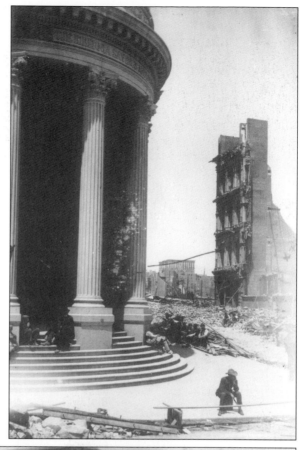

Raised by his mother, Charlotte Hogan, from County Clare, Eugene Schmitz, a bandleader known as "Handsome Gene" and a popular member of the Union Labor Party, was elected mayor in 1902. During the earthquake's aftermath, Schmitz issued a proclamation that all federal troops and police officers were under orders to "shoot to kill" all looters. This act allegedly resulted in the execution of several innocent citizens. (Courtesy Robert Bowen.)

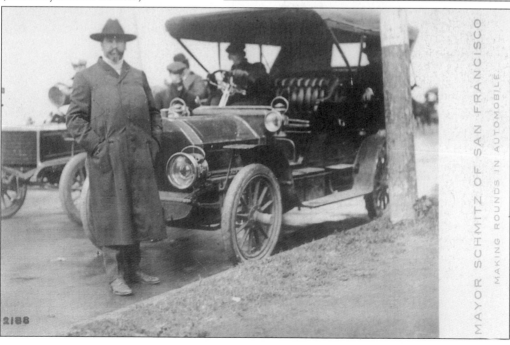

MAYOR SCHMITZ OF SAN FRANCISCO MAKING ROUNDS IN AUTOMOBILE

35

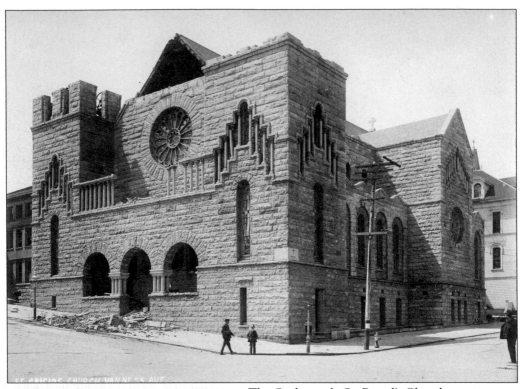

The Gothic-style St. Brigid's Church saw its granite gables fall onto the sidewalk during the 1906 earthquake. When originally built, it was believed to be the only church in the world constructed out of old curbstones. In 1862, St. Brigid's Church was dedicated by Most Reverend Joseph Alemany, the first archbishop of San Francisco. (Courtesy San Francisco History Center, San Francisco Public Library.)

John Joseph Garvey was born in 1884 in Galway, Ireland, to Patrick and Mary, farmers who had 14 children. John came to Boston in 1908 and worked briefly as a streetcar conductor in St. Louis. He dated four women concurrently to ensure one would wed him; pictured here is Elizabeth. Through John Joseph Garvey, this book's author John Garvey obtained dual citizenship in Ireland in 1993. (Courtesy John Garvey Jr.)

At St. Paul's, Fr. Cornelius Kennedy started a group called Kennedy's Indians, named in honor of Native Americans who "lived healthily in the great outdoors and were able to travel great distances on foot." The members of the group were encouraged to do likewise, hiking down the peninsula and setting up a military camp in Santa Cruz. Members included policemen, doctors, dentists, musicians, and priests, as well as Bishop James Sweeney and Archbishop Thomas Connally. (Courtesy Sweeney family.)

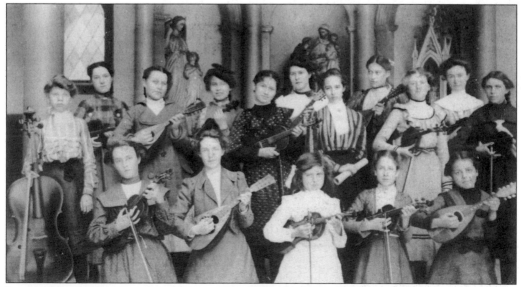

Immaculate Conception Academy in Noe Valley had a tradition of music appreciation and performance, evident in this photograph of one of its early orchestras. Given the population attending this school in that era, it may be ventured that at least two-thirds of these musicians would have been of Irish descent. (Courtesy Immaculate Conception Academy.)

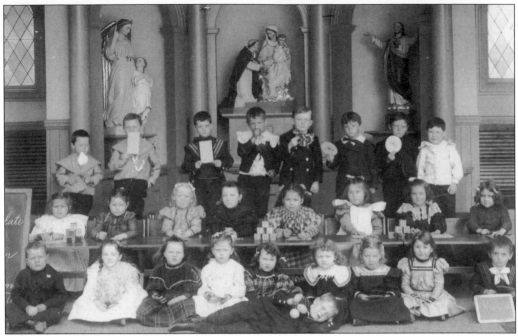

Kindergarteners at Immaculate Conception Academy are pictured here around 1900. (Courtesy Immaculate Conception Academy.)

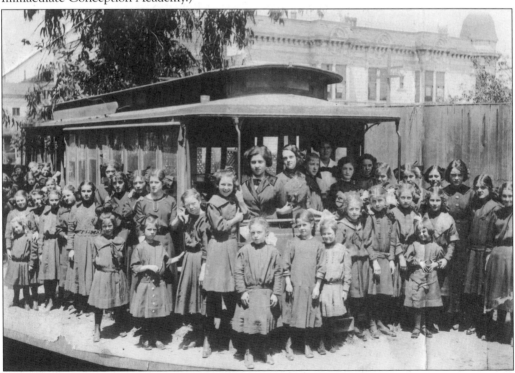

Immaculate Conception Academy students surround a cable car. Years ago, San Francisco had cable cars that crisscrossed the city. Today, however, there are only two main lines: the Powell-Hyde and Powell-Mason, and the California line. (Courtesy Immaculate Conception Academy.)

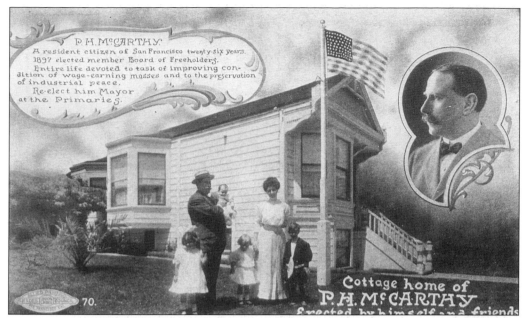

Born in County Limerick on March 17, 1863, P. H. McCarthy was a carpenter and the head of the San Francisco Building Trades Council. He was also elected mayor in 1910. McCarthy's union had won eight-hour days at $3 per day for mill workers; later, under McCarthy's leadership as mayor, this was extended to all city workers. (Courtesy Robert Bowen.)

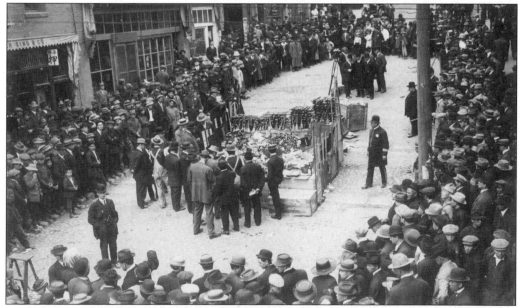

San Francisco witnessed several significant drug busts over the years. In 1911, crates in Chinatown were found containing opium worth $40,000. Some pipes confiscated by law enforcement were elaborately jeweled and worth up to $100 each; some were allegedly not drug items but heirlooms. Still, everything was burned. Police, mostly Irish, felt they had followed the dictates of the law, but the incident created tense community relations. (Courtesy San Francisco Archives.)

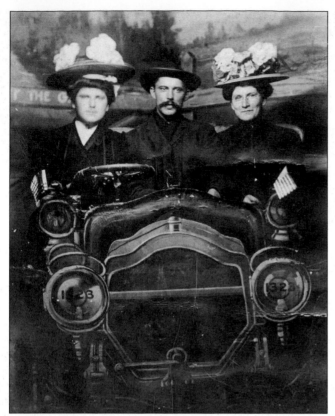

Postcards satisfied the need for personal communication as well as for souvenirs, and sometimes they provided the only memento of an individual, as this image did for Nellie Monahan Cronin (on the right). She died a year or two after this picture was taken, and it became the only picture her family has of her. How fortunate that the group decided, possibly on impulse, to visit "Duhem, the postcard man," the photographer who made the postcard. (Courtesy Greggains family.)

These stalwart young men are members of a group formed by parish assistant, and later pastor, Fr. Cornelius Kennedy to give the young men of St. Paul's parish something beneficial to do. They were known as the Knights of the Cross cadets. (Courtesy Mitchell family.)

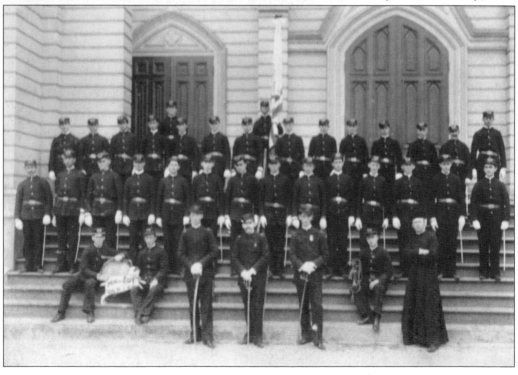

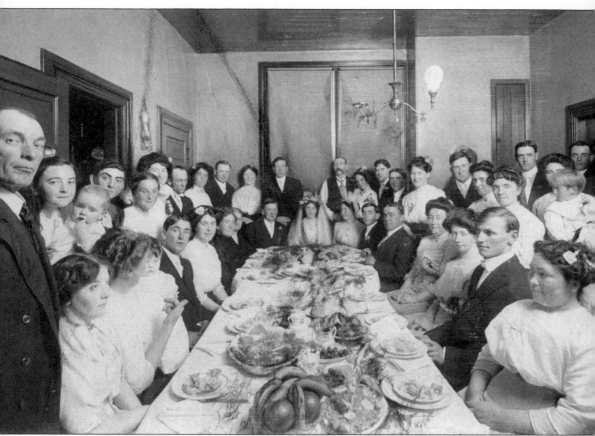

This is the wedding supper of John Mitchell and Anne Sweeney, who are pictured at the far end of the table surrounded by friends and family. Those who have seen the documentary *Neighborhoods of San Francisco*, produced by public television in the Bay Area, have already seen this picture. It appears just as the narrator states, "At the turn of the century, the Mission had it all!" This was a bit funny to those who knew one of the family tales. Later, Anne used to tell how she had begged her mother to let her make curtains for the parlor and the dining room of their house, but her mother thought this was a frivolous expense and vetoed the idea. Thus it was amusing to hear the voiceover at that point in the film, and some found themselves chuckling, "Yes—everything but the curtains!" (Courtesy Mitchell family.)

Peter Maloney was unique in that five of his sons became police officers concurrently: four with the San Francisco Police Department (SFPD) and one with the Denver Police Department. The record, however, is held by the Boston Police Department with a family of nine men all members of the force. (Courtesy Betty Garvey.)

Edward Maloney was one of the first San Francisco police officers to die in the line of duty after he was shot in the back while struggling with a Barbary Coast thief. The entire police force attended his large funeral at St. James Church. The coffin was accompanied by many city dignitaries and all of Edward's brother officers in uniform, shown here. (Courtesy Betty Garvey.)

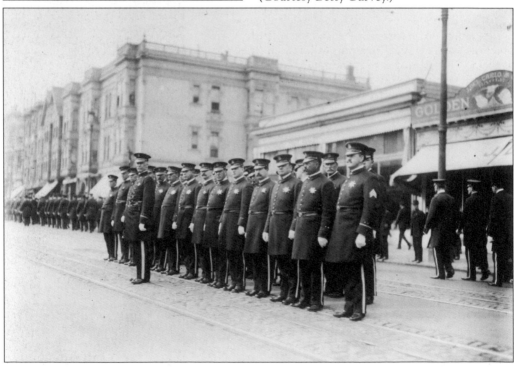

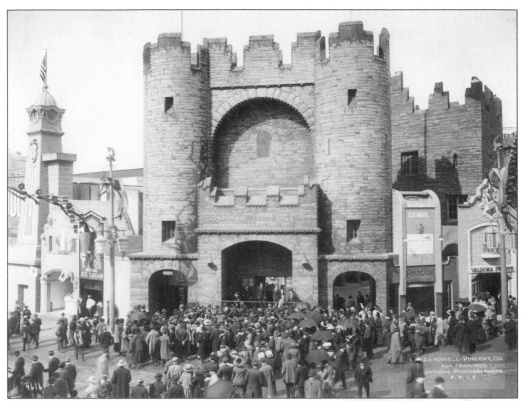

This authentic-looking castle was part of the Irish
section of the Panama-Pacific International Exposition
of 1915. There are several images of this impressive
construction, some carrying the traditional Irish
greeting *cead mile failte* (meaning "a hundred thousand
welcomes") on a banner over the gate. The exhibit was
well attended. (Courtesy San Francisco History Center,
San Francisco Public Library.)

In her finery and fashionable hat, Anne Sweeney poses
at the 1915 exposition. Every effort was made to give the
impression that San Franciscans drove the latest and
most elegant of the new horseless carriages. (Courtesy
Sweeney family.)

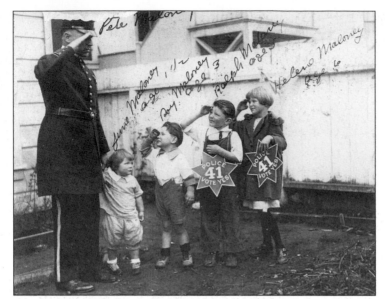

Pete Maloney of the SFPD, who ran for sheriff in the mid-1940s, recruits help for a picture promoting Amendment 41, which would provide employees of the SFPD with a raise from $140 to $170 per month. Like many early proposals in the city that favored improvements to police and fire services, it was successful. (Courtesy Maloney family.)

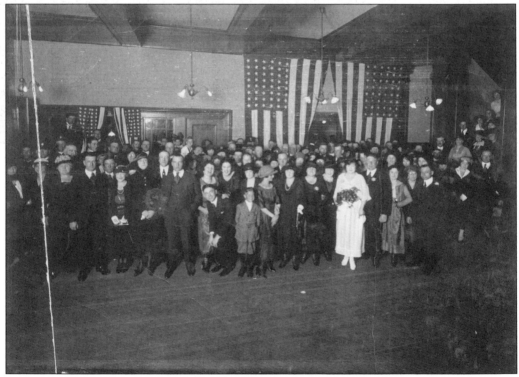

A Raise-in-Salary Dance was held for the SFPD at Park Police Station, near Kezar Stadium, in Golden Gate Park in November 1919. It celebrated the passing of Amendment 41, which authorized an increase of $30 in the monthly salary of each regular police officer. (Courtesy Warren Maloney.)

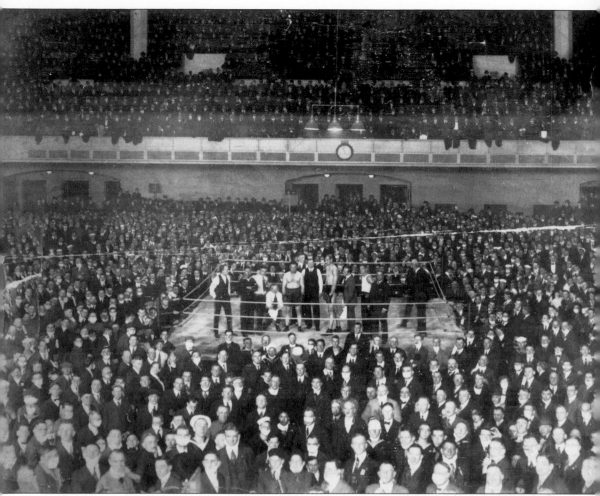

Civic Center Auditorium was the spot for many early sporting events involving the manly art of fisticuffs, an extremely popular sport in the Irish community. This event, held on November 16, 1918, was special, however, because it was a "One Round Go" benefit for the United War Work of World War I. The sponsors for the occasion included Capt. Theodore Roache and Lt. D. J. O'Brien. This event drew a large number of eager spectators. (Courtesy Warren Maloney family.)

Ever wonder about those who went back to Ireland? Well, here are two, both named Pat. Above is Pat who built many improvements to his parents' house and acquired a much-loved pony and jaunting car. Unfortunately, the night before the visit of his brother and newly ordained priest nephew, the old family home burnt down. Luckily other relatives were ready to receive them. (Courtesy Finnegan family.)

Here is "Big Pat" Sweeney (as opposed to his American nephew, "Little Pat"), who returned to his hometown of Coolmacranaught and was ever afterward dubbed "the Yank" by his neighbors, by whom he was consulted as an authority on anything at all pertaining to America. (Courtesy Finnegan family.)

Nora Donahue ran a boardinghouse providing lodging, entertainment, and dances and enabling young adult natives of her former home to socialize and acquire mates. Women would sometimes write to Nora asking her if good men in America needed wives. (Courtesy Sweeney family.)

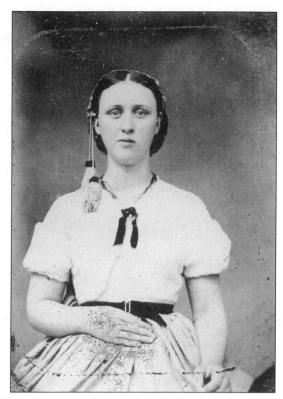

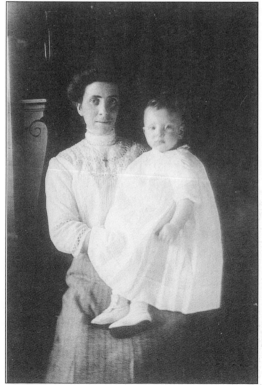

One of many Irishwomen earning their living in wealthy homes, Julia Kennedy appears here holding her young charge, Antoinette Zellerbach. Julia's grandniece remembered that when new laws allowed women in California to vote in 1911, Julia returned from the polls, saying, "Now that we women can vote, we should do it." (Courtesy Sweeney family.)

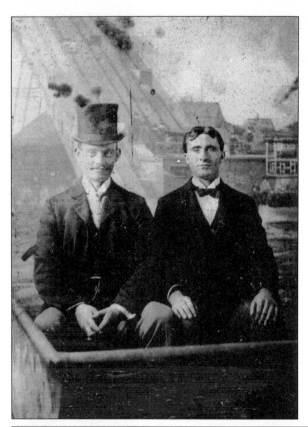

Shoot the Chutes, a popular Haight Street Waterpark ride, used ramps and flatboats to give patrons the thrill of hurtling down a smooth slide into a receiving pond. Flat-bottomed boats charged down a 350-foot water flume that was 70 feet above the water. Joe Sweeney is pictured on the right. (Courtesy Sweeney family.)

On the far left are Mary McTeran and her husband, Gateano Vella, who was born in Malta and came to the United States as a cabin boy at the age of 14. Mary, who emigrated from Ireland, was institutionalized at Agnes State Mental Hospital in her later years after she became mentally ill. (Courtesy Lorelie Fulwider.)

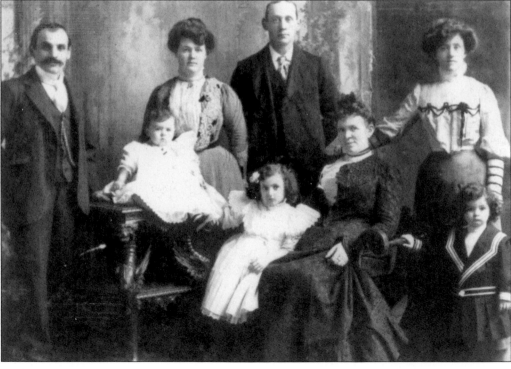

Michael Coll, a baker, and his wife, Maria Coffey Coll, both died just months after this picture was taken. One of Maria's sisters wanted to send the couple's six children to an orphanage, but another sister decided instead to raise them. Michael's cousin Eamon de Valera, who served as president of Ireland for two terms from 1959 until 1973, was born in New York City in 1882 to Catherine Coll, from County Limerick, and her Spanish husband, Juan de Valera. (Courtesy Gregory Zompolis.)

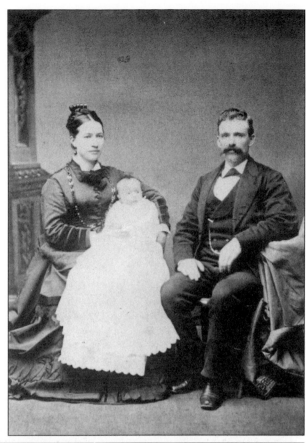

President of the first Dail Eireann, the parliament of the revolutionary Irish Republic, Eamon de Valera issued this bond to Joseph Mitchell in 1920 during the Anglo-Irish War, the Irish war of independence. During an American tour, De Valera raised over $5 million through the sale of Republican bonds. (Courtesy John Garvey Jr.)

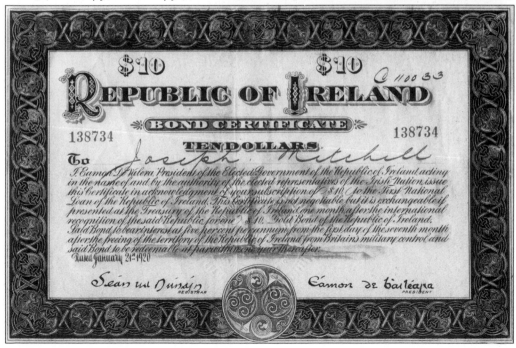

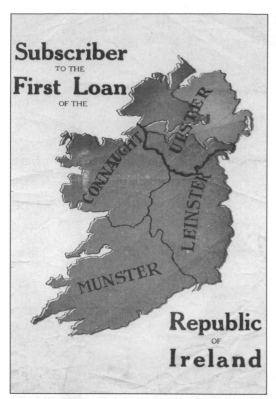

Subscriber to the First Loan of the Republic of Ireland certificate shows the Republic in green and the North in orange. It was issued to contributors of money collected on Eamon de Valera's fund-raising trip to the United States following his escape from Lincoln Jail in 1919. He traveled the United States advocating the sale of bonds to create a National Credit by way of an external loan to the republic. (Courtesy John Garvey Jr.)

Eamon de Valera unveils a statue of executed Irish patriot Robert Emmet in Golden Gate Park in July 1919. De Valera's American citizenship helped save his life when the Easter Uprising rebels were executed. His work contributed greatly to the creation of an independent Ireland; De Valera died in 1975. (Courtesy San Francisco History Center, San Francisco Public Library.)

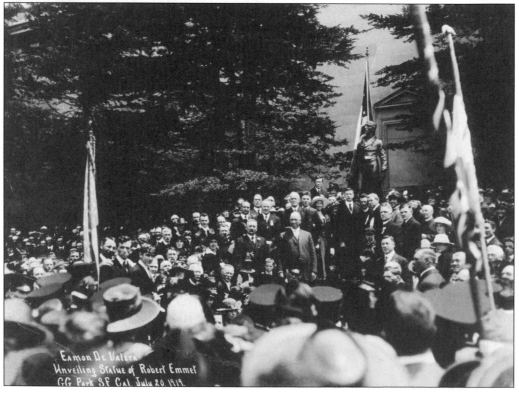

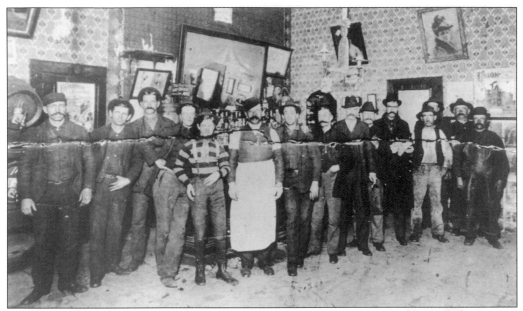

The Cookoo's Nest was a popular spot for, particularly, police and firefighters who wanted to unwind, drink a cold steam beer, and mingle with other immigrants. The establishment no longer exists. (Courtesy Warren Maloney.)

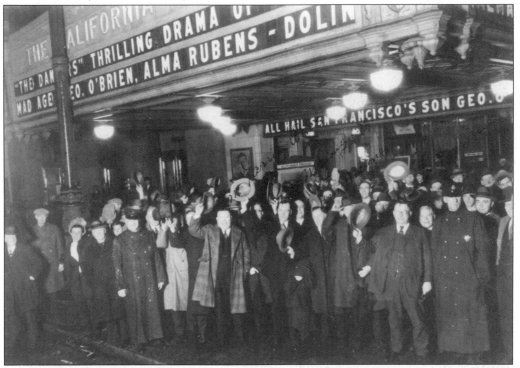

In this February 10, 1925, photograph, the California Theatre on Mission Street proclaims, "All hail SF's son, George O'Brien," at the premiere of his first big film, *The Dancers*. Among George's credits were *The Iron Horse* and other Westerns. George's father, Daniel O'Brien, was San Francisco's chief of police. (Courtesy Warren Maloney.)

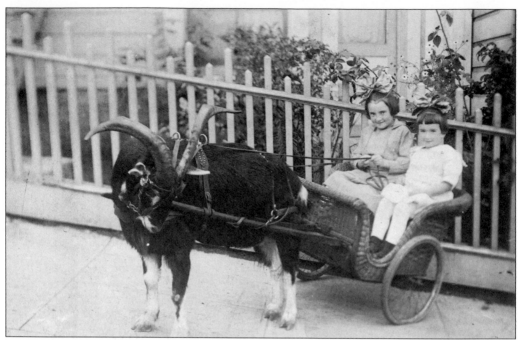

It is a typical scene. A man with a camera comes by with an animal and gets all the neighborhood kids excited. They come out to see the goat cart or the pony, and then he gets their parents to spring for pictures. Here are Marie and Rose Mitchell in a goat cart around 1918. (Courtesy Holian family.)

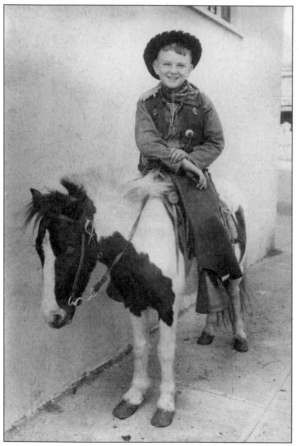

These examples from the streets of San Francisco span the generations. In the 1918 photograph above, Marie and little sister Rose pose in a goat cart. In this c. 1950 image, Marie's son Phil Holian—in full cowboy attire supplied by the enterprising photographer—rides a pony. (Courtesy Holian family.)

A San Francisco landmark at 760 Market Street, the Phelan Building was an 11-story office building constructed in 1908. The early steel-framed building is an exquisite example of Victorian architectural style. The white exterior is adorned with glazed terra cotta, while the inside is graced with a two-story white marble lobby and elevator. (Courtesy San Francisco History Center, San Francisco Public Library.)

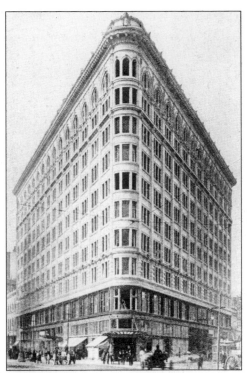

Born in May 1864 in Jointer, Ireland, Michael Maurice O'Shaughnessy was selected by Mayor "Sunny Jim" Rolph to be chief engineer for San Francisco on September 1, 1912. O'Shaughnessy's largest and most controversial undertaking was the Hetch Hetchy Project in Yosemite National Park, which created a dam in the Sierras linked by more than 150 miles of tunnels, pumping stations, and pipelines to provide water to San Francisco. (Courtesy San Francisco History Center, San Francisco Public Library.)

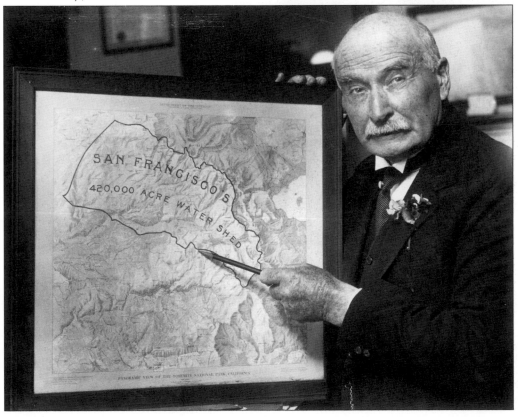

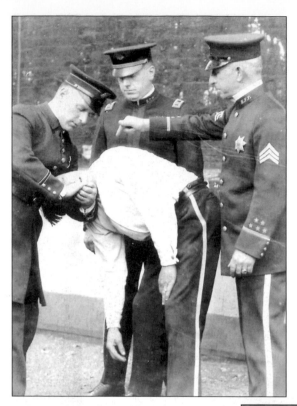

Shown here is the "strangle hold" used then by the San Francisco Police Department. From left to right are Peter Maloney, William Quinn, Sgt. Pat McGee, and the subject George Hess. Sergeant McGee is well known for waking up in the city morgue a half an hour after being brought there lifeless. (Courtesy Warren Maloney.)

Peter Maloney, a member of the SFPD beginning in 1919 and for a total of 28 years at retirement, is seen here at his desk in city hall in 1937, when he was Mayor Angelo Rossi's personal bodyguard and chief of staff. Maloney was the founder of the well-known South of Market Boys, begun in 1924 to "promote friendship, maintain character, and perpetuate memories" among those raised "South of the Slot." (Courtesy Warren Maloney.)

Pictured from left to right around 1928, Edward Garvey, John Garvey Jr., and Francis Garvey were the proud sons of John and Elizabeth Garvey. The boys had two sisters they never knew—Mary A. and Mary E.—who both died days after they were born. Edward became a prominent ear, nose, and throat doctor; John, the president of the International Council for Urban Liaison; and Francis, an accountant. (Courtesy Claudia Curran.)

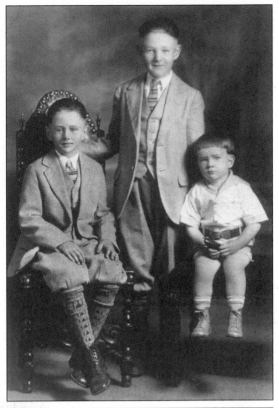

Here young Thomas Maloney Jr., son of senator Tom, interviewed his uncle, Officer Pete Maloney, and Capt. William J. Quinn for a school project on good citizenship in March 1923. They are pictured in the office of then SFPD Chief Daniel O'Brien, father of movie actor and star George O'Brien. (Courtesy Maloney family.)

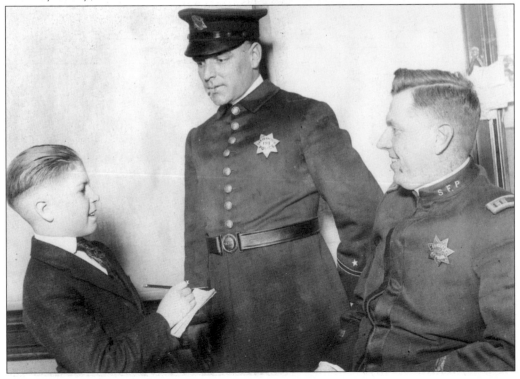

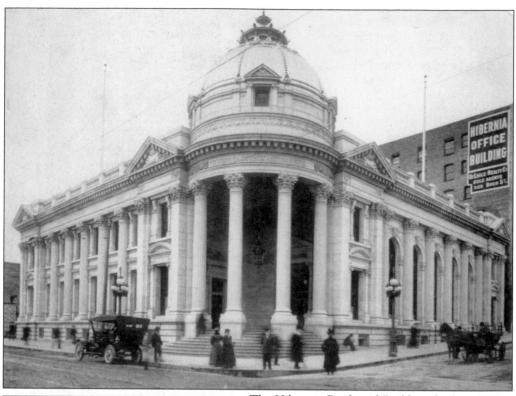

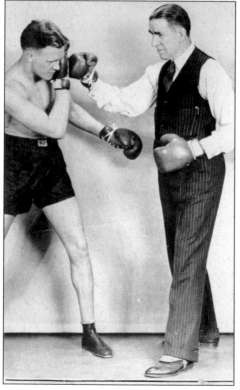

The Hibernia Bank and Building, built in 1892 at Jones and Market Streets, was bought out by Crocker Bank and was subsequently acquired by Wells Fargo. On April 15, 1974, the members of the Symbionese Liberation Army, accompanied by Patty Hearst, robbed another Hibernia Bank in San Francisco. In 1976, Hearst was convicted in U.S. District Court for the Hibernia Bank robbery and sentenced to seven years in prison. (Courtesy San Francisco History Center, San Francisco Public Library.)

Boxer "Gentleman" Jim Corbett was a member of the San Francisco Olympic Club and worked as a bouncer at the North Beach establishment now called the San Francisco Brewery Company. The saloon, now the last standing bar of the Barbary Coast, opened its doors in 1907 as the Andromeda Saloon. Andromeda earned wide respect in 1913 when Jack Dempsey gained employment there and went on to become world heavyweight boxing champion. (Courtesy San Francisco History Center, San Francisco Public Library.)

George "Machine Gun" Kelly is considered one of the most famous gangsters of the Prohibition era. At Alcatraz Prison, he was inmate AZ No. 117. He took a job as an altar boy in the prison chapel, worked in the laundry, held an administrative role in the industries office for a long period, and generally served out his time quietly, while boasting about several robberies and murders that he never committed. (Courtesy San Francisco History Center, San Francisco Public Library.)

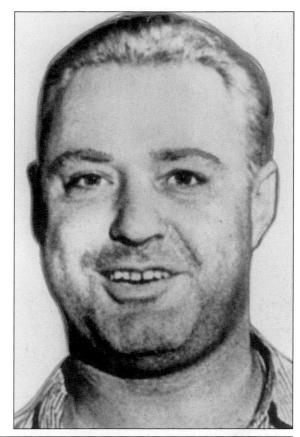

These men are machinists who worked at the Fairbanks-Morse Company in the 1930s and 1940s. (Courtesy Mary Rielly.)

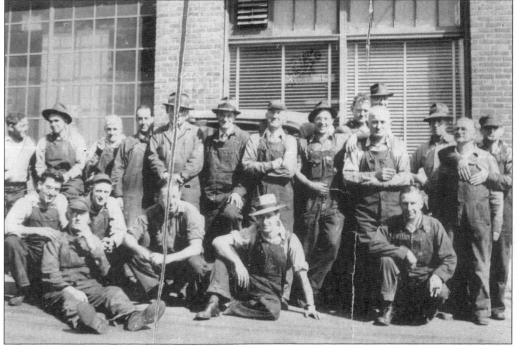

At St. James School in the Mission—"one of the most Irish parishes in the city"—the boys' group known as the San Francisco Singers was very popular and had become quite well known, performing at many local events and others further afield. Here they are pictured on May 20, 1935, with their director, Brother Anthony, S.M., standing to the right. (Courtesy Mary Rielly.)

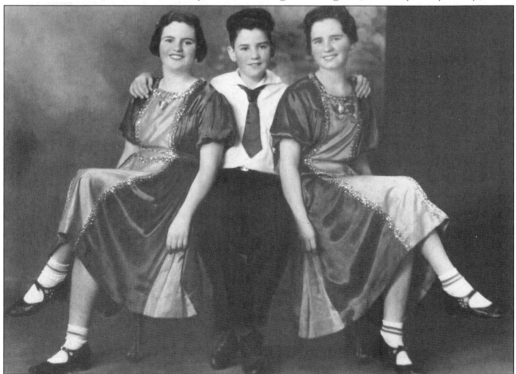

The three Hurley children—Aileen (left), Joe, and Margaret—won prizes for their dancing. The girls' dresses are green and gold and their cheeks pink, and their darling brother looks like a teen idol. (Courtesy Sister Edith Hurley.)

The Healy Irish Dance School has taught classic Irish dancing for more than 100 years, and issued these diplomas to graduating students. Aileen Hurley's skills and those of her brother may be judged by the previous picture. Many young people in San Francisco have been exposed to Irish dancing via the Healy School and other fine studios throughout the city. (Courtesy Sister Edith Hurley.)

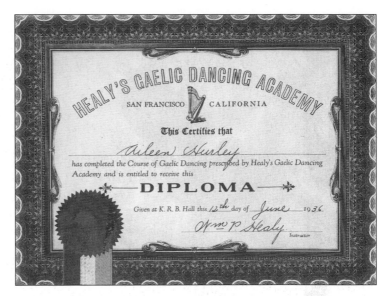

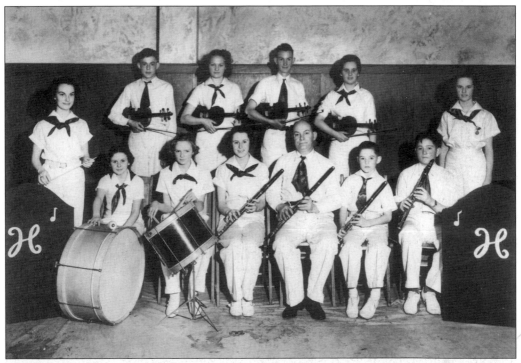

Healy's Irish Orchestra provided music for their dancers and performed at many public events and competitions. William Hurley, their talented leader, is in the center with a flute. The orchestra also performed at the annual St. Patrick's Day Parade down Market Street to the city hall plaza. (Courtesy Hurley family.)

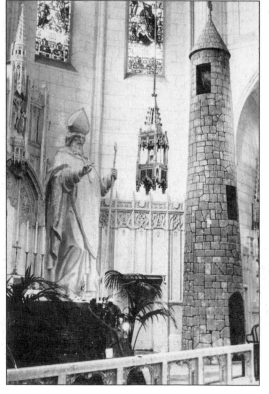

Frank "Lefty" O'Doul was a native San Franciscan, a pitcher, and a strong batter for the Seals, Yankees, Red Sox, Giants, Phillies, and Dodgers. He was also a successful manager and important figure in the establishment of professional baseball in Japan. O'Doul's fame lives on through the names Lefty O'Doul's Bar and O'Doul Bridge. His gravestone states, "He was here at a good time, and had a good time while he was here." (Courtesy San Francisco History Center, San Francisco Public Library.)

Dating from 1851, the neo-Gothic St. Patrick's Church was founded to serve San Francisco's Irish community. That commitment is reflected in the church's gold, green, and white decor. The columns on either side of the nave are Connemara green marble imported from Ireland. Tiffany stained-glass windows glow brightly beneath the vaulted ceiling. The church was destroyed in the 1906 earthquake but was rebuilt with bricks from the ruins. (Courtesy San Francisco History Center, San Francisco Public Library.)

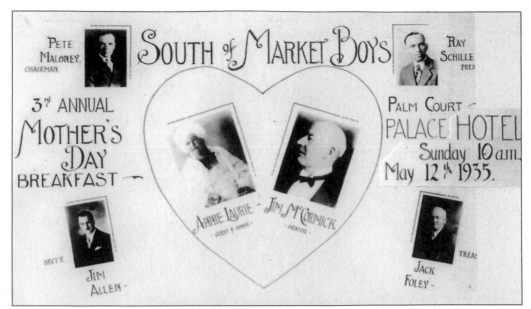

Annie Laurie, the pen name of popular female *Examiner* columnist Winnifred Black, was the honorary "mother" of the South of Market Boys men's group. The organization held an annual Mother's Day breakfast each year. This 1935 invitation states that Laurie would be the guest of honor at the Palm Court of the Palace Hotel, where the breakfasts were often held. (Courtesy Warren Maloney.)

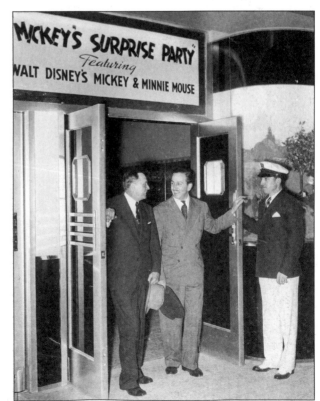

In this rare image, Walt Disney attends a screening of *Mickey's Surprise Party*. This early Mickey Mouse film was shown on San Francisco's Treasure Island during the 1939 World's Fair. The reaction of the crowd to this Irish American's creative genius was very positive. (Courtesy San Francisco History Center, San Francisco Public Library.)

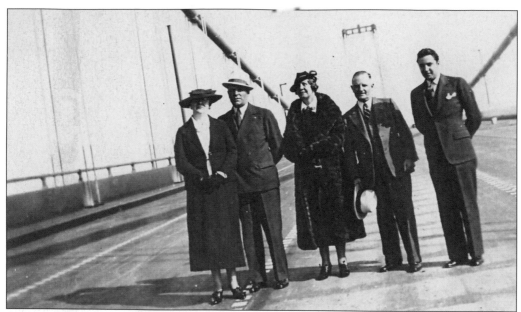

Peter Maloney (second from left) and friends take a stroll across the new Golden Gate Bridge on opening day in 1937. A chance to go on a similar walk in the middle lanes would not take place again for 50 years, when the recent anniversary brought out a crowd so large that the bridge swayed under their combined weight. (Courtesy Ginny Maloney.)

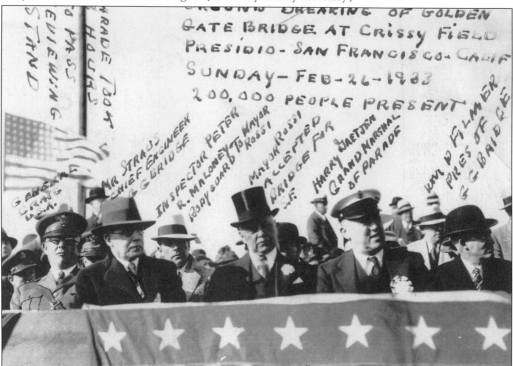

The Golden Gate Bridge ground-breaking at Crissy Field was the occasion of a festive gathering on February 26, 1933, with all the designers and various public figures in attendance. (Courtesy Ginny Maloney.)

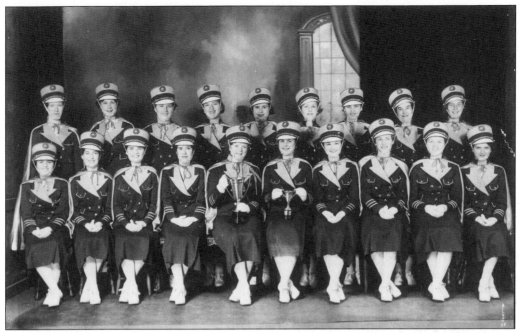

The Rebel Cork Ladies was organized in 1914 for women from or descended from parents who hailed from County Cork. The group is still active as a benevolent association and usually marches in the St. Patrick's Day Parade, but membership requirements have been modified to include women with only one ancestor from Cork. (Courtesy Sister Edith Hurley.)

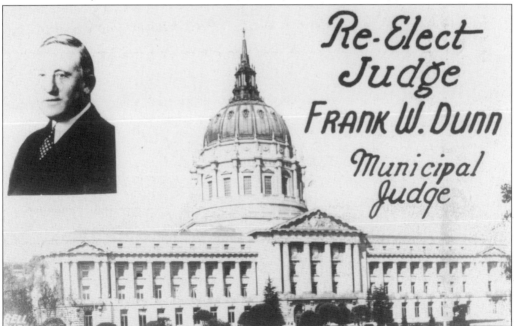

Frank Dunn made his bid for mayor during the reign of another very popular San Francisco son who served in that capacity, Mayor Angelo Rossi. So there was little shame in losing to Rossi, who retained the mayoral seat for over a decade, from 1931 to 1944. Dunn served in other administrative capacities for the city government. (Courtesy Robert Bowen.)

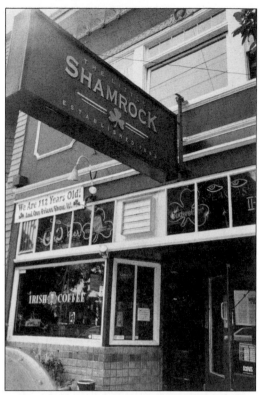

The Little Shamrock bar, on Lincoln Way by Golden Gate Park, was established in 1893 and remained open through Prohibition to the present day. (Courtesy author Karen Hanning.)

John Neary hoists a last pint at Casey's Bar. Unfortunately, this establishment would soon close as Prohibition got underway. (Courtesy Mary Reilly.)

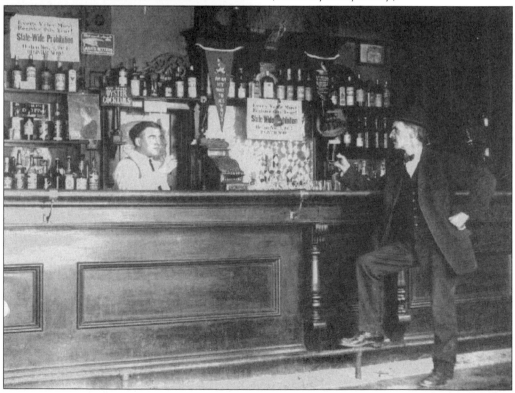

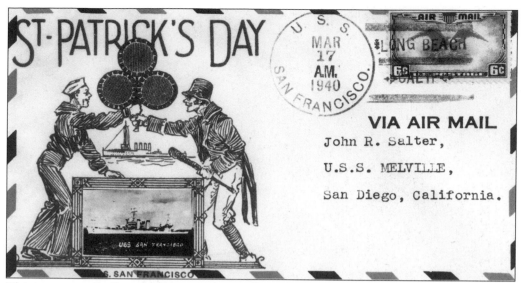

This is a prewar St. Patrick's Day postal cancellation of USS *San Francisco* CA-38. The "Frisco," a New Orleans–class heavy cruiser, was the second ship of the U.S. Navy named after the city of San Francisco. She saw extensive action during World War II, earned 17 battle stars, and became the second most decorated U.S. warship. Twenty-three navy ships have been named after men who served on the CA-38, some with Irish ancestry. (Courtesy USS San Francisco Memorial Foundation.)

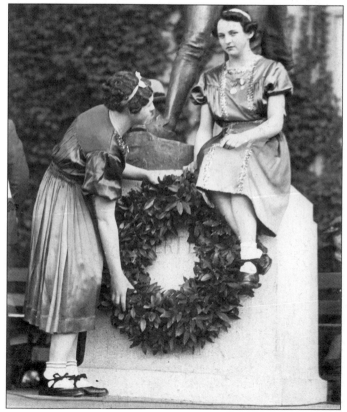

Marie and Josephine Sheehan are pictured in 1937 at the Robert Emmet statue in Golden Gate Park. Emmet came from a family of Irish patriots and was expelled from the University of Dublin for his involvement in the 1798 rebellion. A member of the United Irishmen's Party, Emmet traveled to France in 1802 to appeal, unsuccessfully, to Napoleon and Talleyrand for French aid in his quest for Irish independence. (Courtesy San Francisco History Center, San Francisco Public Library.)

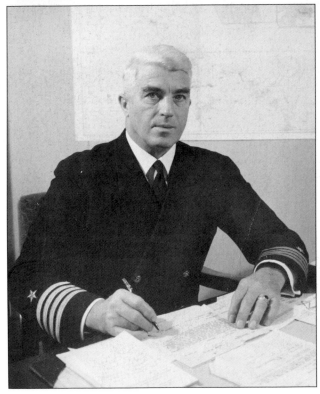

These altar boys were photographed outside St. Patrick's Church in 1939. This parish is now heavily supported by Filipino parishioners, and a mass in Tagalog is celebrated the first Sunday of each month at 2:00 p.m. (Courtesy San Francisco History Center, San Francisco Public Library.)

Named for a grandfather who left Cork in the 1840s, Rear Adm. Daniel Callaghan was born to a devout Catholic family of San Francisco merchants and attended the Jesuit St. Ignatius High School. He graduated from the Naval Academy in Annapolis in 1911, ranking 38th in a class of 193, and was assigned to the USS *San Francisco* CA-38 during World War II. He earned a Medal of Honor posthumously at the Battle of Guadalcanal. (Courtesy San Francisco History Center, San Francisco Public Library.)

Born in Ireland, actor Victor McLaughlin, though not a city resident, often stayed in San Francisco in his early years as a boxer. In 1941, the South of Market Boys invited him to a benefit dinner in honor of many old-time fighters who were then aging in the city of their early triumphs. His letter, pictured here, thanks them for the invitation. (Courtesy Warren Maloney.)

A Red Mass is celebrated in Old St. Mary's Cathedral in 1942. Held annually in the Catholic faith, the Red Mass requests guidance from the Holy Spirit for all who seek justice. The service is often attended by judges, prosecutors, attorneys, law school professors and students, firefighters, police officers, and government officials. (Courtesy San Francisco History Center, San Francisco Public Library.)

Victor McLaglen Light Horse

3231 Hyperion Avenue
LOS ANGELES, CALIFORNIA

April 25, 1941.

Mr. Pete Maloney,
General Chairman, Old Time Boxers,
707 - 26th. Ave,
San Francisco, California.

Dear Pete;

I expect to be on a Personal Appearance Tour the next few weeks, but will assure you I will make your date if I am in California.

I think it the most interesting affair I have heard of, and it certainly would be grand to meet some of the old foggies I met forty years ago. If unable to be there will send you a wire.

Nice to hear from you Pete and hope to see you soon.

Sincerely,

Victor McLaglen

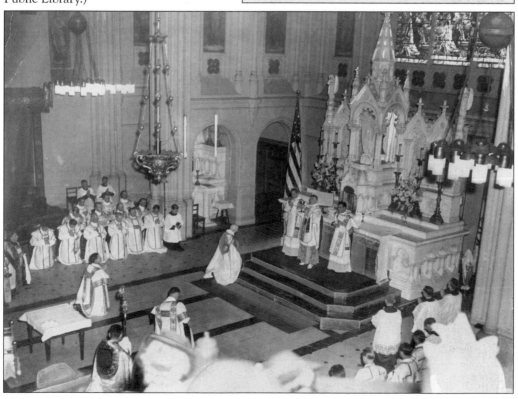

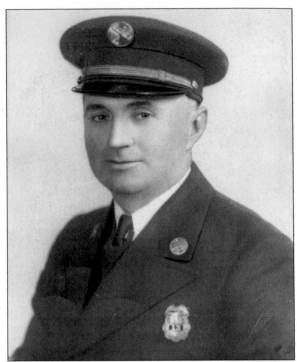

Edward Walsh served as San Francisco's fire chief from 1948 to 1953. Today his legacy is kept alive by the San Francisco Fire Department Historical Society (SFFDHS). The primary mission of the SFFDHS is to preserve the heritage and to record the history of the San Francisco Fire Department (SFFD). This mission includes the conservation and preservation of the collection, as well as the display of documents, fire memorabilia, and apparatus at the SFFD Museum. (Courtesy San Francisco History Center, San Francisco Public Library.)

Many in the Irish community attended this Holy Thursday mass in 1942. (Courtesy San Francisco History Center, San Francisco Public Library.)

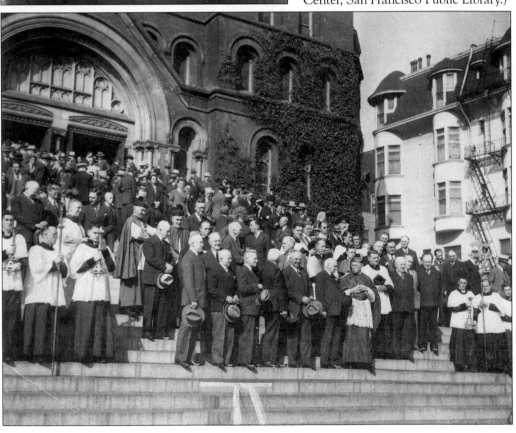

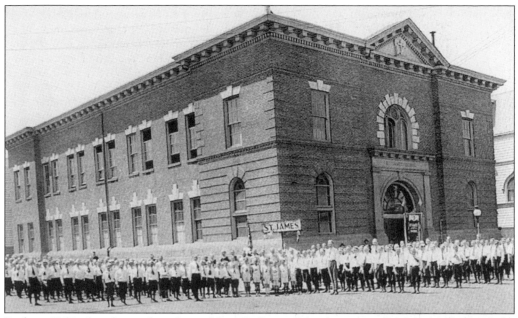

Built in 1907, after the earthquake and fire, St. James School was one of the original schools for boys in San Francisco. Staffed by brothers of the Society of Mary, St. James School, nicknamed "the Old Brickpile," added a high school curriculum to its grammar school curriculum in 1924 and was the primary Catholic high school for boys in the Mission District by 1949. That year, it closed and transferred its efforts to the newly built Riordan High School, the only school in San Francisco to be named for a local archbishop. (Courtesy Riordan High School.)

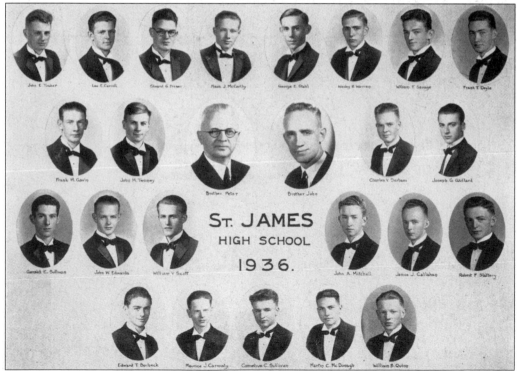

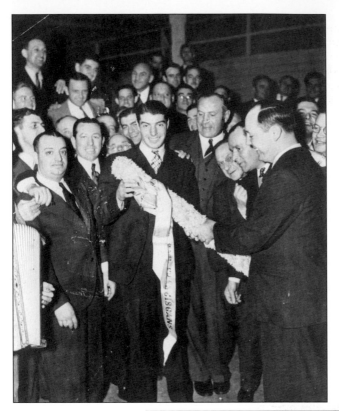

Pete Maloney, at right, and many other members of the South of Market Boys threw a farewell party for Joe DiMaggio when he left the San Francisco Seals to join the New York Yankees. (Courtesy Warren Maloney.)

The Irisher at 141 Mason Street was one of the city's most colorful cocktail lounges. Here is a napkin from the establishment that depicts a lovely lass with a shamrock. This club is no longer in operation. (Courtesy author John Garvey.)

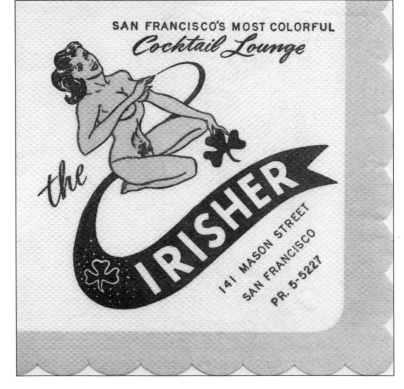

SAN FRANCISCO'S MOST COLORFUL
Cocktail Lounge

the
IRISHER

141 MASON STREET
SAN FRANCISCO
PR. 5-5227

"Baby Day" at St. Paul's was a treasured tradition held as students prepared to make the transition from grammar school to high school. For one nostalgic day, the girls got the chance to be kids again, wearing youthful dresses and hair ribbons and bringing dolls to school. (Courtesy Alice Mitchell.)

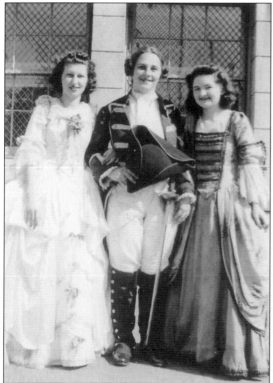

Thespian activities were popular at St. Paul's, but since it was a single-gender school, girls had to take the "trouser roles" as well as the conventional female roles. Here a handsome "soldier" is accompanied by two characters in elegant ladies' attire. (Courtesy Alice Mitchell.)

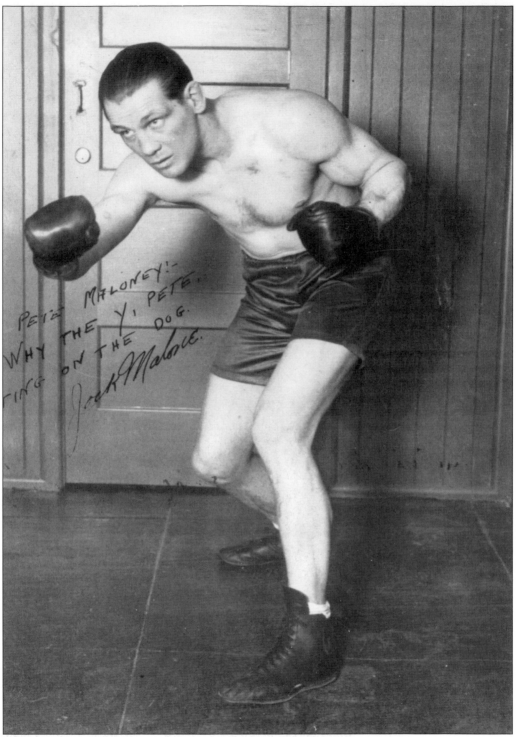

Jack Maloney, who boxed in his younger days, changed his last name to "Malone" for easier public usage. Pictured here in classic boxing stance, Jack was known to be one of the hardest hitters that ever came out of the city, and his strong hands stopped many men. (Courtesy Warren Maloney.)

The USS *Mississippi* (BB-41) battleship, after an overhaul at San Francisco, sailed from San Pedro to take part in the invasion of the Gilbert Islands. Any ship docking in the city on St. Patrick's Day provided its crew with enthusiastic participation in the festivities (Courtesy author John Garvey.)

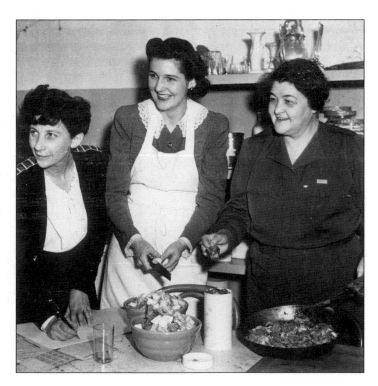

In February 1944, Mrs. Roger Sturdevant, Mrs. Stanhope Nixon, and Mrs. Joseph Pease prepared dinners for San Francisco's many "Rosie the Riveters." Mrs. Sturdevant, supervisor of the Golden Gate Kindergarten Association, checks ration points, while Mrs. Pease of the Junior Auxiliary and Mrs. Nixon, state president of the American Women's Voluntary Services (AWVS), dish up delicious Irish stew for a take-home food service begun for the working mothers of nursery school youngsters during World War II. (Courtesy San Francisco History Center, San Francisco Public Library.)

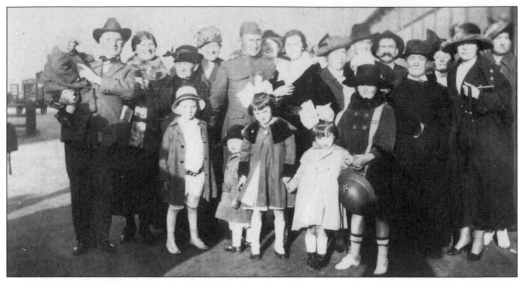

This family portrait was taken upon Ed Mitchell's return from World War I, where he had fought in France and been taken prisoner. As a POW, he was quite lucky because he was given to an older German couple who needed help running their farm. In time, he was treated as a member of their family and stayed with them several years. They corresponded for many years after the war ended. (Courtesy Edward Mitchell family.)

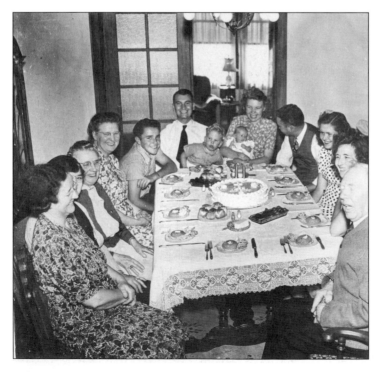

At the extreme other end of the POW experience, Edward Mitchell's son Bill was one of the few to survive the Bataan Death March during World War II. The different experiences of this father and son highlight the differences between the two wars and illustrate the great changes the world went through in the period between the wars. Bill was lucky to return home, and it was the occasion of a reunion for his relations. (Courtesy Bill Mitchell.)

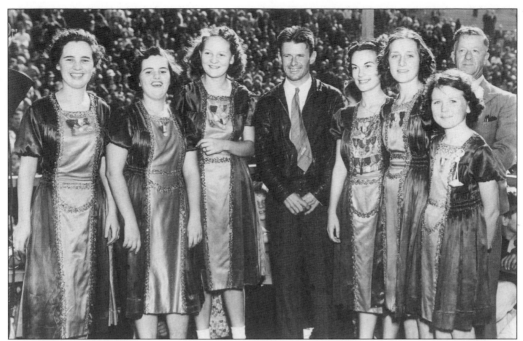

The Healy Irish Dancers entertain famous pilot Douglas "Wrong Way" Corrigan, who, after having been denied permission for a nonstop flight from New York to Ireland in 1935 by the Bureau of Air Commerce, took off from New York and "turned the wrong way." Afterward Corrigan enjoyed quite a bit of publicity, some positive and some negative. He became somewhat of a celebrity and, judging by his grin here, found his experiences rather more pleasurable than otherwise. (Courtesy Sister Edith Hurley.)

Sculptor Jerome Connor's statue of Irish patriot Robert Emmet is pictured here in 1945 in front of the California Academy of Sciences building in Golden Gate Park. The beautiful statue was donated to the city of San Francisco by former mayor and Irishman James D. Phelan. Emmet led an uprising outside of Dublin that was quickly crushed by the British. He was hanged on September 20, 1803, at the age of 25. (Courtesy San Francisco History Center, San Francisco Public Library.)

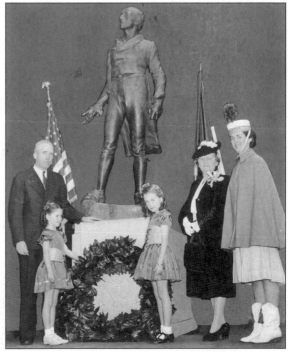

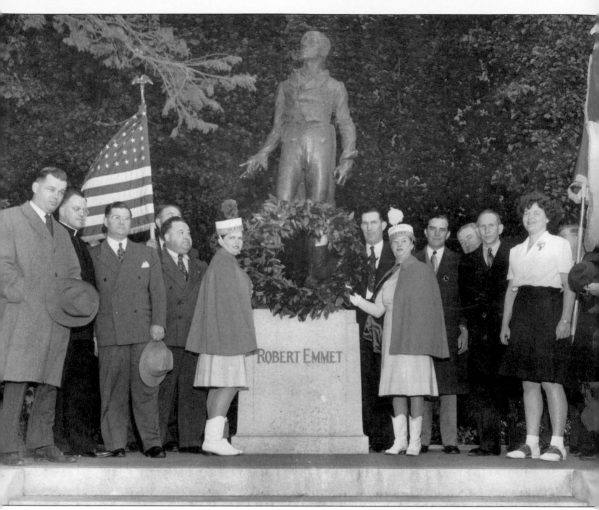

The United Irish Societies conduct annual Robert Emmet Day exercises in Golden Gate Park in 1946. The bronze statue was cast in Philadelphia. The base is granite, and six steps with granite coping lead up to the platform around the statue. The architect of the base was Charles E. Gottschalk, who had earlier designed James Phelan's residence in Saratoga. (Courtesy San Francisco History Center, San Francisco Public Library.)

Drum majorette Barbara Mercer proudly marches down Market Street during the 1947 St. Patrick's Day Parade, stepping high to lead her drum corps to music by McNamara's Band. (Courtesy San Francisco History Center, San Francisco Public Library.)

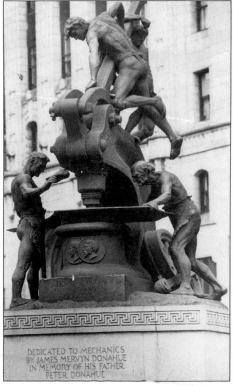

The majestic bronze sculpture known as the Mechanics Monument, on Market Street, was created by Douglas Tilden in 1901. The artwork was commissioned and funded by James Mervyn Donahue, the son of Irish blacksmith Peter Donahue who established the first foundry on the Pacific Coast, the Union Ironworks. Peter manufactured the first printing press in the West and then built the first city railway on the Pacific Coast. Donahue also founded the San Francisco Gas Company, which later evolved into Pacific Gas and Electric. (Courtesy San Francisco History Center, San Francisco Public Library.)

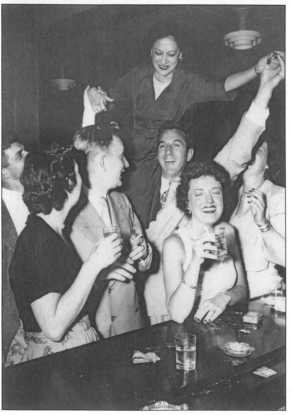

Just looking at these pictures is like going to a party—never let it be said the 1950s were not a great era for letting the good times roll. Florence Barry, drink in hand, takes a break from her serious duties and responsibilities as a nurse and whoops it up with her friends. (Courtesy Mary Barry.)

Three

1950–PRESENT

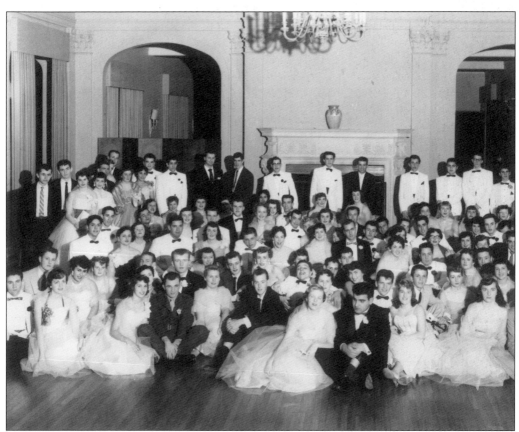

"Dancing in the Dark" was the theme for the 1954 junior and senior prom at Immaculate Conception Academy. Here the happy couples of both classes take part in the main social event of the season. Girls wore puffy dresses, and boys rented a tux or wore whatever jackets they had and the regulation bow tie. (Courtesy Immaculate Conception Academy.)

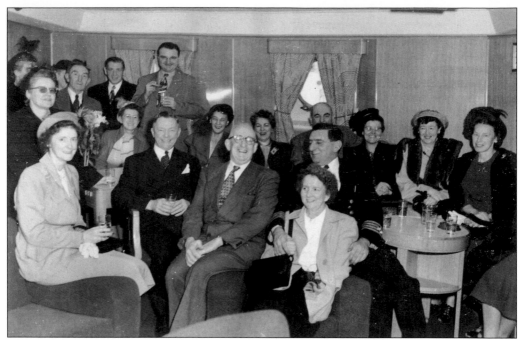

Here is a glimpse of a momentous occasion—the entry of the first ship to fly the Irish flag into San Francisco Harbor. At Pier 41, aboard the SS *Irish Plane*, well-known members of the city's Irish community were invited to celebrate the great event. Since the West Coast was probably about as far from the Emerald Isle as one could get, this was doubtless a cause for celebration, as Ireland could then congratulate itself as a more wide-ranging seafarer, fulfilling the promise of its then relatively new standing as an independent nation. Years later, on October 28, 2007, airline Aer Lingus announced the introduction of direct flights from San Francisco to Dublin four times weekly. (Courtesy Mibeck-Lynch family.)

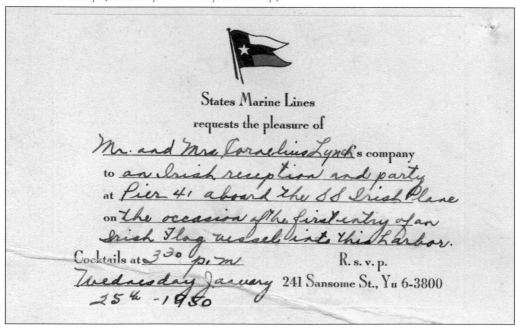

States Marine Lines
requests the pleasure of

Mr. and Mrs. Cornelius Lynch's company
to an Irish reception and party
at Pier 41 aboard the SS Irish Plane
on the occasion of the first entry of an
Irish Flag vessel into this Harbor.
Cocktails at 3:30 p.m. R. s. v. p.
Wednesday January 241 Sansome St., Yu 6-3800
25th - 1950

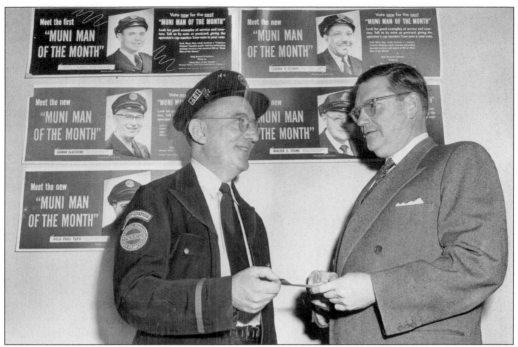

Philip Landis (right) presents Joseph P. Sullivan with a $50 check for being the "Muni Man of the Month" in March 1951. San Francisco Municipal Railway (Muni), founded in 1912, is one of America's oldest public transit agencies. (Courtesy San Francisco History Center, San Francisco Public Library.)

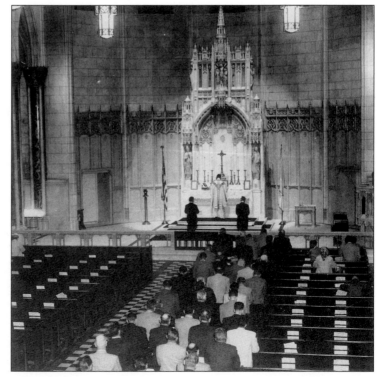

The interior of St. Patrick's Catholic Church is seen during a solemn smoke-eaters (firemen) mass. Outside across from the church today is Yerba Buena Gardens, which has a collection of restaurants, shops, museums, and plenty of open space for the public to enjoy. Across the esplanade is Sister City Gardens, which has several plants indigenous to Ireland. This enchanting place with waterfall sounds is available daily for visiting. (Courtesy of San Francisco History Center, San Francisco Public Library.)

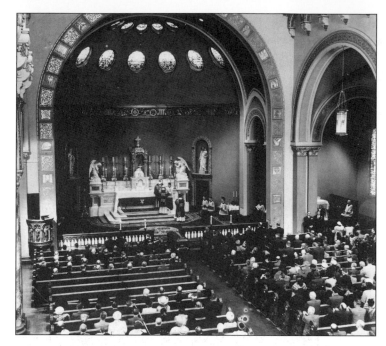

St. Brigid's Church contains many treasures: stained-glass windows from Harry Clarke Studios in Dublin, Ireland; a Ruffatti pipe organ custom made in Italy; and statuary by *c.* 1900 California artist John McQuarrie and the famed Irish sculptor Seamus Murphy. Murphy carved the faces of the 12 apostles for the monumental statues on the front of the church, using the heroes of the 1916 Easter Uprising as his models. (Courtesy San Francisco History Center, San Francisco Public Library.)

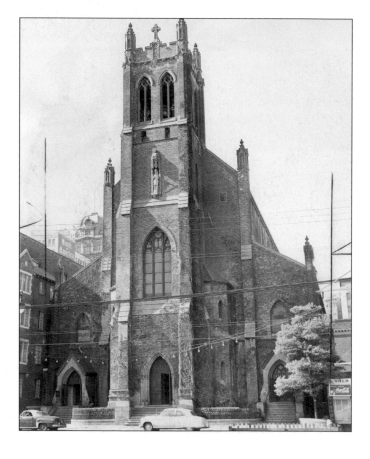

Pictured here in 1953, St. Patrick's Catholic Church at 756 Mission Street is a landmark 1851 Gothic Revival red-brick building. Sites adjacent to St. Patrick's will be the future locations of the Mexican Museum and the Jewish Museum. (Courtesy San Francisco History Center, San Francisco Public Library.)

San Francisco City Hall's elevator operator Jim Healy works on St. Patrick's Day in 1953. Notice the large shamrock, "caed mille failte" sign, and the American and Irish flags in the elevator cab. (Courtesy San Francisco History Center, San Francisco Public Library.)

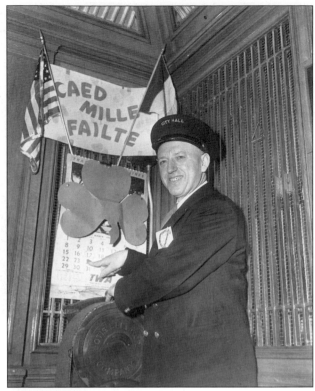

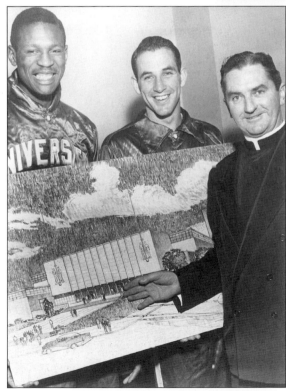

University of San Francisco Dons basketball players Bill Russell and Jerry Mullen hold an architect's rendering of a proposed new War Memorial Gymnasium in March 1955. At right is Fr. John F. Connolly, USF president. After graduating from USF, the 6-foot-9-inch Russell enjoyed a successful career with the Boston Celtics. (Courtesy San Francisco History Center, San Francisco Public Library.)

On June 6, 1953, brothers Larry and Jack Mitchell opened Mitchell's Ice Cream at San Jose Avenue and Twenty-ninth Street in San Francisco. Larry and Jack were no strangers to the dairy business, as the family owned and operated a small dairy farm in San Francisco in the late 1800s. The store began as a neighborhood ice cream shop, but it was not long before restaurants and cafés began requesting their ice cream and sorbets for their menus. Over the years, the Mitchells gained renown not only for manufacturing premium gourmet ice cream but also for making exotic tropical flavors. They import avocado, buko (baby coconut), guava, langka (jackfruit), macapuno (sweet coconut), mango, pineapple, and ube (purple yam) fruit for their ice cream, and they use fruit such as lychee and passion fruit for their delicious sorbets. (Courtesy Larry Mitchell.)

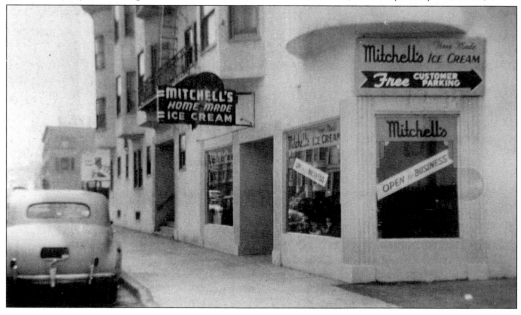

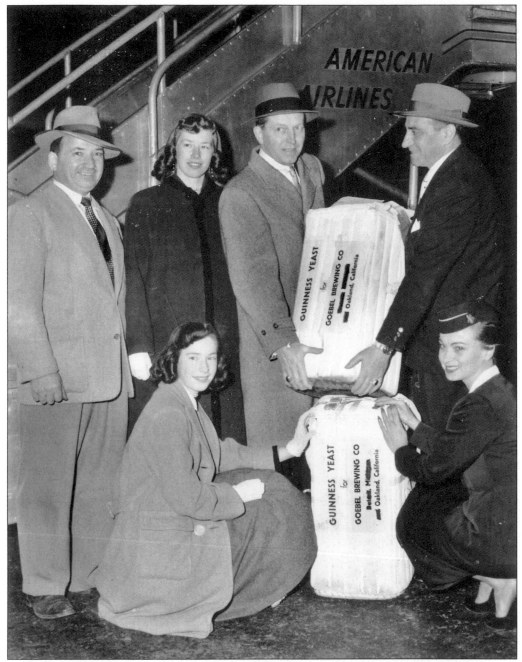

Until the 1950s, a pint of genuine Guinness could not be freshly made in the Bay Area, but with the first shipment of bags of the special grain, such a thing finally became possible. Word came late one night in 1950s that the shipment, so long anticipated, had arrived at the San Francisco Airport. Quickly, Mr. Lynch and his daughters drove to the plane's landing area to greet it. The publicity would have been greater, but since the father's underage daughter was included in the picture, the newspapers of the time discreetly declined to publish some of them. While this was the first shipment in history sent to the Bay Area, the first recorded shipment of Guinness to the United States was to South Carolina in 1817. (Courtesy Lynch-Mibeck family.)

Jerry Brown was born in San Francisco, the only son of former San Francisco lawyer, district attorney, and later Democratic governor Edmund G. "Pat" Brown Sr. Jerry graduated from St. Ignatius High School and studied at Santa Clara University. In 1958, he entered Sacred Heart Novitiate, a Jesuit seminary, intending to become a Catholic priest. However, Brown left the seminary and entered the University of California at Berkeley, from which he graduated with a degree in classics in 1961. Brown went on to Yale Law School and was later elected governor of California and mayor of Oakland. (Courtesy Steve Finnegan.)

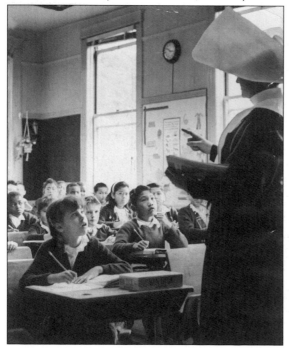

This teaching nun at St. Patrick's Grammar School in 1961 still wears her "flying nun" headdress. Soon many nuns stopped wearing habits, most of which were throwbacks to the normal clothes of the era when their orders were established, in favor of simpler modern clothes. (Courtesy San Francisco History Center, San Francisco Public Library.)

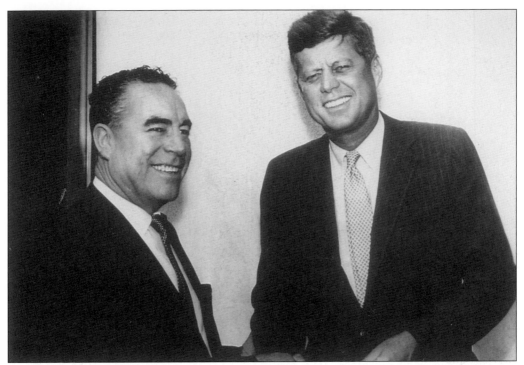

Pres. John F. Kennedy lends his support to San Francisco native Emmet Hagerty during his congressional seat run. Kennedy came to San Francisco and is most remembered for his 1960 appearance at the Cow Palace with his "Staffing a Foreign Policy for Peace" speech. His brother Robert Kennedy was in San Francisco the day before he was assassinated in Los Angeles in 1968. (Courtesy Robert Bowen.)

This is an exterior view of the Arthur J. Sullivan funeral home at 2254 Market Street in the heart of the Castro District. Since 1924, the Sullivan family has been providing funeral services for families of the Bay Area. They joined with the Bud Duggan family—including Madeline, Bill, and Dan Duggan—of Duggan's Serra Mortuary in 2006. (Courtesy Alan Canterbury.)

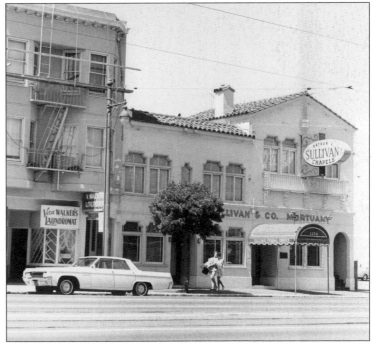

John Francis "Jack" Shelley served as the mayor of San Francisco from 1964 to 1967. He was the first Democrat elected to the office in 50 years and became the first in an unbroken line of Democratic mayors that lasts to the present day. Shelley was mayor during 1967's Summer of Love, a time of radicalism centered in the Haight-Ashbury neighborhood and turmoil throughout the city. (Courtesy San Francisco History Center, San Francisco Public Library.)

The authentic "jaunting car" was specially ordered from Ireland by Mr. Lynch for use in the St. Patrick's Day Parade in 1958. It was handmade by the most prominent manufacturer of this antique style of transportation in that country. Naturally the sight of a real Irish jaunting car drew much attention, helping promote the fine restaurant run by the Lynches at 532 Jones Street. (Courtesy Lynch-Mibeck family.)

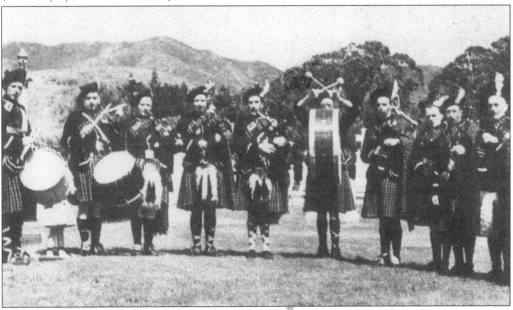

Here the San Francisco Irish pipers play their yearly tribute at the grave of Father Yorke, the early labor priest. They are in demand for Highland Games, weddings, parades, and funerals. (Courtesy Maureen Kelleher Lennon.)

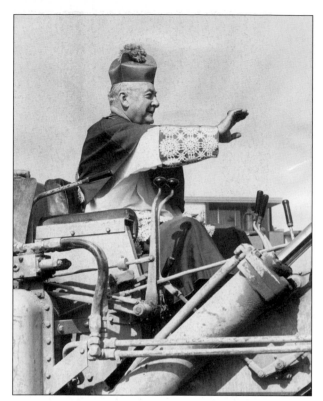

On February 21, 1962, Pope John XXIII appointed Bishop Joseph McGucken the fifth archbishop of San Francisco. McGucken was installed on April 3, 1962. At the same time, His Holiness announced a sweeping change in Northern California diocesan boundaries with the creation of three new dioceses: Oakland, Santa Rosa, and Stockton. McGucken is remembered for the planning and construction of a new St. Mary's Cathedral after it was destroyed in a 1962 fire. (Courtesy San Francisco History Center, San Francisco Public Library.)

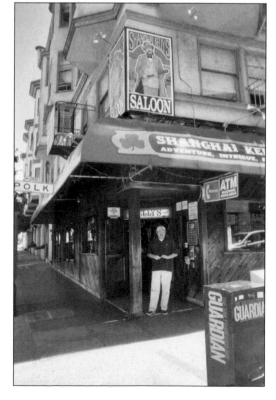

Legendary Barbary Coast villain Jim "Shanghai" Kelly, the namesake of the bar pictured here, was a pub owner who contracted with ship's captains to provide them with needed crews. Kelly resorted to drugged "mickeys" and would swoosh the inebriated through a trap door and into a rowboat that would take them to the ship where they would awaken as members of the crew. In a case of poetic justice, Kelly was never heard from again after he, himself, was shanghaied. (Courtesy author Karen Hanning.)

The Camp Mather complex began as residences for the builders of O'Shaughnessy Dam, part of the Hetch Hetchy water project to provide the city water. Michael O'Shaughnessy, the dam's namesake and chief engineer, emigrated from Ireland in 1885. Once the project was complete, the structures became a city camp. These happy campers enjoy a horseback ride. (Courtesy Lynch-Mibeck family.)

This young Casey bathing beauty with inner tube enjoys a cool dip in Camp Mather's kids' pool. (Courtesy Casey family.)

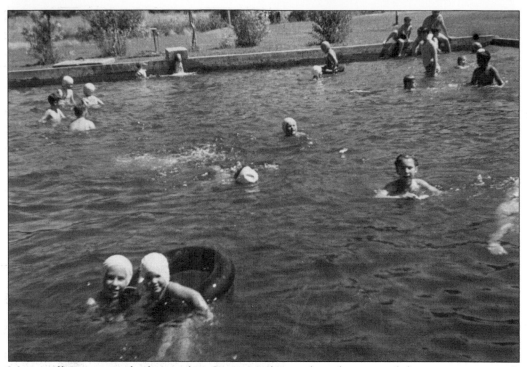

Many will recognize the big pool at Camp Mather and maybe some of the swimmers, too. It provided a great place to cool off on summer days. To many of Irish descent, Camp Mather took on the aspect of a "home away from home" during the summer. (Courtesy Casey family.)

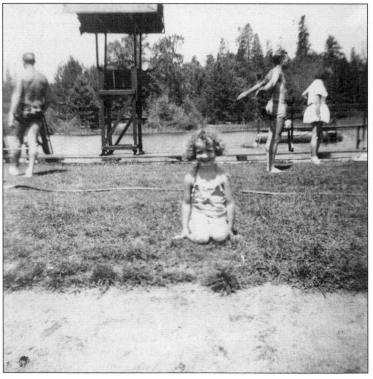

Barbara Casey recalls that while she was at Camp Mather, LeeAnn Meriweather, the future Miss America of 1955, was camp activities director and that meal tickets were checked by young Robert Brannick, now Dr. Brannick, a local orthopedic surgeon. (Courtesy Casey family.)

Daniel Cronin of Day Street and daughter Nora survey their potato patch, which appears to be coming along well. Sometimes called the "Irish staff of life," the tubers are under the ground and, being the root of the plant, must be dug up in order to be harvested. (Courtesy Patti Greggains.)

The corner of Day and Church Streets has been a popular hangout since the early years of the century. When this photograph was taken, the more utilitarian corner was home to a grocery store run by Mickey Genotti, who appears on the right in his apron. The cellar access, guarded by a rectangle of pipes, was a hangout for Irish lads. (Courtesy Patti Greggains.)

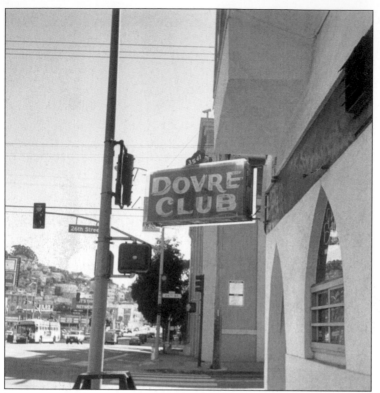

Dovre Club was a mainstay of the surrounding Irish community when it first opened at Eighteenth Street off Mission Street. The place often participated in fund-raising for the Irish Northern Aid Committee. Paddy Nolan, the club's legendary proprietor, was often mentioned by columnist Herb Caen. When he died, the women's center owned it, controversially terminating its lease in favor of a day care. The Dovre Club was then moved to its present location on Valencia Street. (Courtesy author Karen Hanning.)

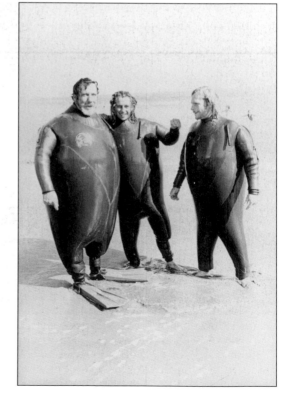

From left to right, Jack, Pat, and Mike O'Neill demonstrate the "supersuit" they developed to survive in the ocean overnight. The O'Neills owned the first surf shop on Wawona Street in the 1950s and a second shop on the Great Highway that became a surfing landmark. The O'Neills were very progressive and ingenious. (Courtesy San Francisco History Center, San Francisco Public Library and Jack O'Neill.)

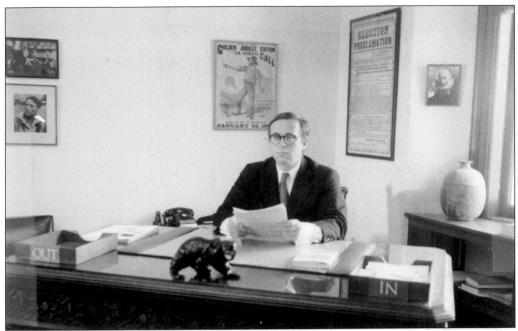

San Francisco native and former state librarian Kevin Starr is a prominent Irish-descended California historian and professor at the University of Southern California in Los Angeles. He is the recipient of a Guggenheim Fellowship and the gold and silver medals from the Commonwealth Club of California. (Courtesy San Francisco History Center, San Francisco Public Library.)

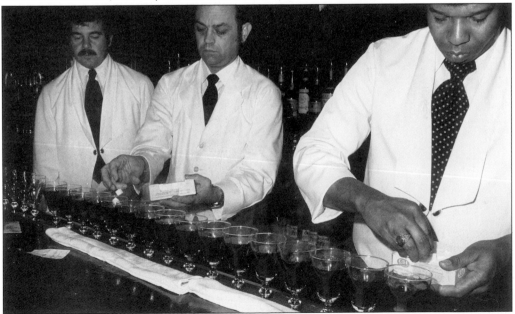

On the night of November 10, 1952, Jack Koeppler, the owner of the Buena Vista bar, challenged international travel writer Stanton Delaplane to help him re-create a highly touted "Irish coffee" served at Shannon Airport in Ireland. This event marked the first introduction of Irish coffee to America. Then mayor George Christopher, a dairy owner, successfully advised frothing cream aged for 48 hours to a precise consistency. (Courtesy Mary Anne Kramer.)

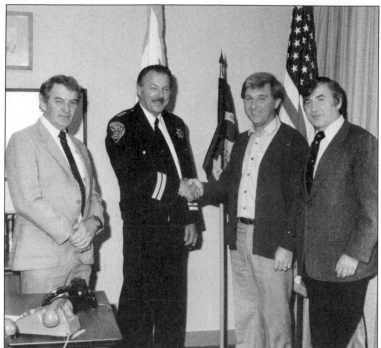

From left to right, Golden Gate Bridge director John Moylen, SFPD chief Cornelius Murphy, an unidentified delegate from Ireland, and Diarmuid Philpott meet in 1978. These men shared a common bond in their love and respect for their Irish culture and heritage. (Courtesy Diarmuid Philpott.)

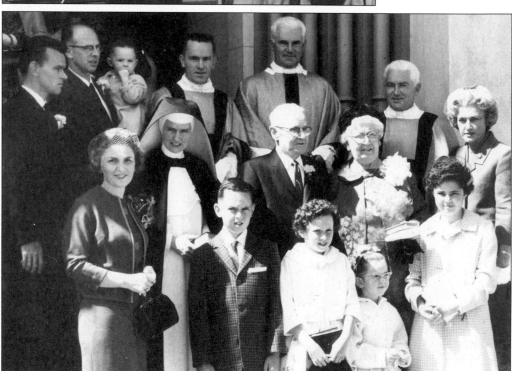

On the steps of St. James Church, where they married 50 years before, Thomas Rielly and his wife, May Neary Rielly, gather with their family, including their seven children: three priests, one married son, one nun, and two married daughters (one not pictured here). (Courtesy of Mary Rielly.)

Shown here is Harrington's Pub, a "no-frills" place at the corner of Larkin and Turk Streets, at the edge of San Francisco's Tenderloin. Signs above the bar—such as "If your baby needs shoes, don't drink here" and "The bank doesn't make beer, the bar doesn't loan money"—set the tone. (Courtesy Mary Anne Kramer.)

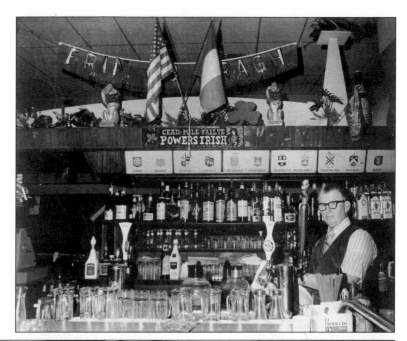

The town of Colma became the location of a large number of cemeteries when San Francisco passed an ordinance in 1900 outlawing the construction of any more cemeteries in the city and then passed a 1912 ordinance evicting all existing cemeteries from the city limits. Following the relocation of these cemeteries into Colma, the town's motto became "It's Great to Be Alive in Colma," a humorous comment on the community's 1,500 aboveground residents and its 1.5 million underground. Owen Molloy's family owns the only bar in Colma, a mourners' gathering place, and he recalls playing hide-and-seek among the tombstones of various graveyards as a child. (Courtesy Mary Anne Kramer.)

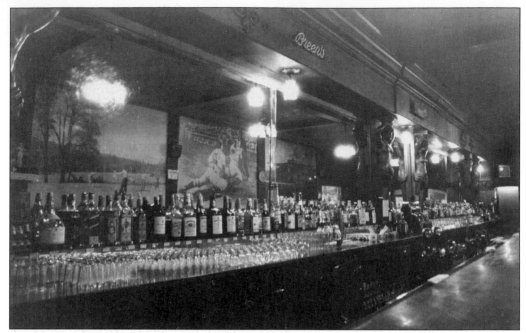

Breen's Rummy Parlor, at 71 Third Street, was a popular Irish pub for newsmen at the nearby *San Francisco Chronicle*. William Saroyan, the prolific, Pulitzer Prize–winning writer, drank here in the 1930s, and in 1939, he wrote the play *The Time of Your Life*, which he set in a waterfront saloon in San Francisco. (Courtesy Mary Anne Kramer.)

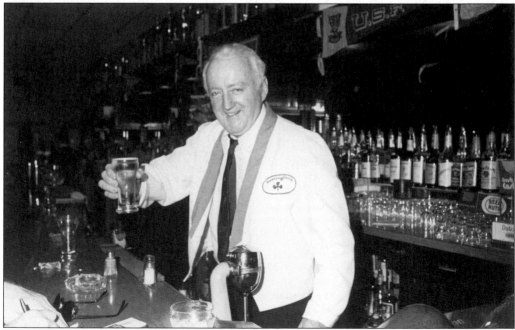

Harry Harrington serves up a drink in 1974. His legacy, Harrington's Bar and Grill on Front Street, is considered the last great traditional Irish pub in the heart of the Financial District. Today it is operated by Kathleen Harrington. Harry also established Harrington's Pub at the corner of Larkin and Turk Streets. (Courtesy Mary Anne Kramer.)

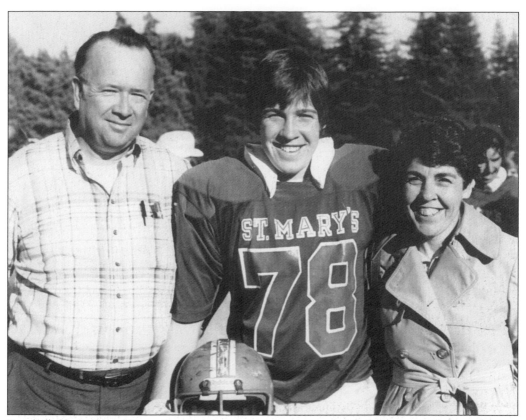

Frank (left), Paul, and Betty Garvey are pictured at St. Mary's College in Moraga. Originally established in San Francisco in 1863 as a diocesan college for boys, St. Mary's moved across the bay to Oakland in 1889 and then to Moraga in 1928. The St. Mary's Gaels had a longstanding football rivalry with Santa Clara University and used a victory bell, reputedly taken from a Liberty ship, as a trophy. The rivalry lasted from 1947 until Santa Clara University stopped playing football in 1992. The Gaels won the final game and retained possession of the bell. (Courtesy St. Mary's College Football Archives.)

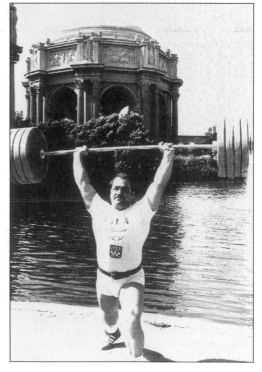

Champion weightlifter Butch Curry practices by the Palace of Fine Arts. Born in New York to Irish parents, Curry moved to San Francisco in the 1970s. He qualified for the Olympic team in 1980, the year the Moscow Olympics were boycotted by the United States. (Courtesy Jim Schmitz.)

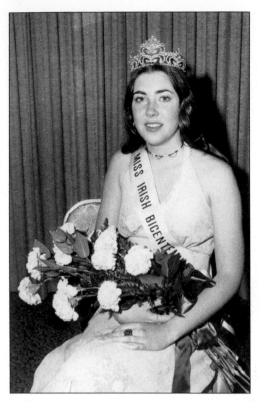

In 1976, San Francisco's Rose of Tralee winner was Colleen Philpott, arrayed here in a traditional crown and flowers but also with a sash commemorating the importance of the bicentennial year. Philpott then journeyed to her father's homeland to take part with other Irish descendants from around the world in this international festival. (Courtesy Diarmuid Philpott.)

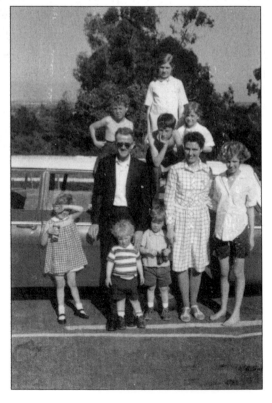

The Meehan family relaxes at El Retiro, a Jesuit retreat house in Santa Clara. This Sunset District family is known for its Meehan Brothers comedy team of Chris, Howard, and Michael. Mike Meehan has been a local comedy legend since the 1980s, with countless appearances at clubs and on television. (Courtesy Michael Meehan.)

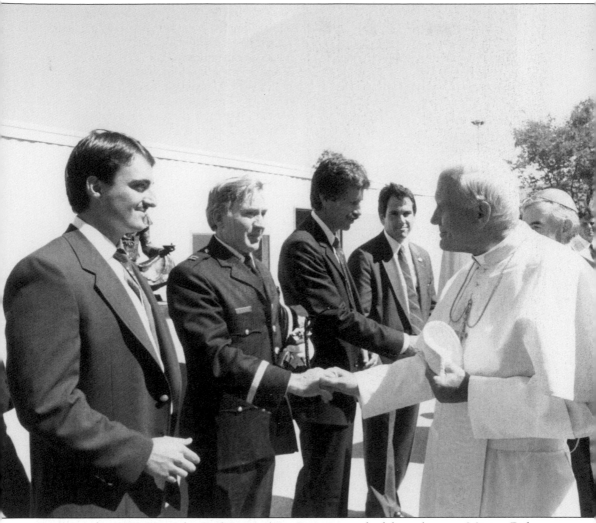

In September 1987, Pope John Paul II visited San Francisco and celebrated mass at Mission Dolores and Candlestick Park. Here he shakes hands with SFPD's Diarmuid Philpott, and behind him, on the right, is then San Francisco archbishop John R. Quinn. The others pictured are security people entrusted to secure the pope while traveling in the United States. (Courtesy Diarmuid Philpott.)

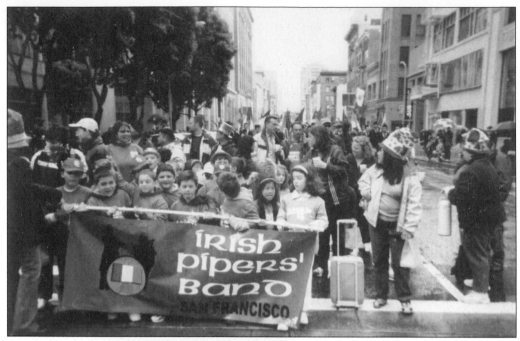

San Francisco's Irish pipers march in the 2005 St. Patrick's Day Parade, on Second Street turning up Market Street. Youngsters enjoy this early portion of the parade route because the floats are loaded with free candy that is tossed to the crowds. (Courtesy author John Garvey.)

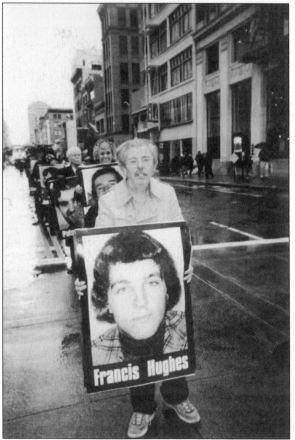

Mike, a resident of the Glen Park area, honors Irish hunger striker Francis Hughes by carrying his picture in the 2005 St. Patrick's Day Parade. (Courtesy author John Garvey.)

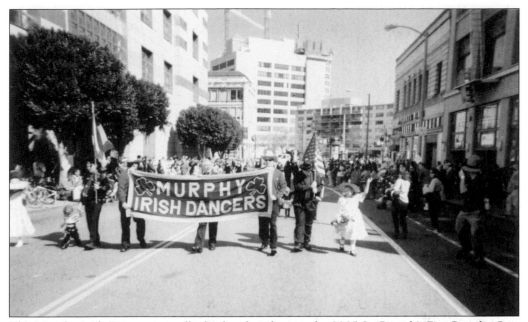

The Murphy Irish Dancers proudly display their logo at the 2005 St. Patrick's Day Parade. One of many Irish dance schools in the Bay Area, Murphy's was started by Mary Jo Murphy and is carried on by her daughter, Trish Feeney-Conefrey. (Courtesy author John Garvey.)

All Things Irish, now at 634 Taraval Street, was operated at Twenty-sixth and Valencia Streets for 40 years by a lady named Moore, a fellow immigrant of one of the present owners. Deirdre Daly and Geraldine Pritchard moved the business to its present location and continue to offer fine Belleek china and jewelry, as well as an assortment of T-shirts, cards, books, flags, and Irish teddy bears. (Courtesy D. Daly and G. Pritchard.)

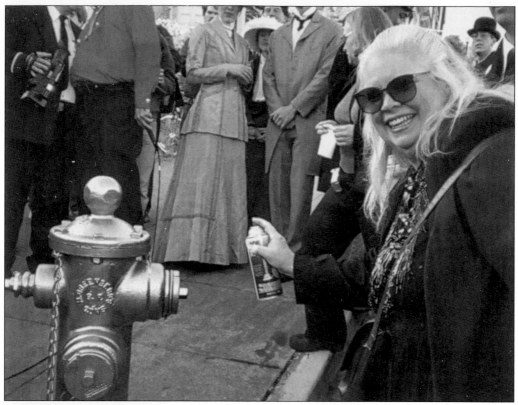

Here Author Karen Hanning takes part in the special 2006 commemoration of the quake and fire by helping in the traditional yearly spray gilding of the fire hydrant at the upper end of Dolores Park, in gratitude for the fact that its unbroken water supply saved the rest of the then largely Irish Mission District—including two of her great-grandparents' homes—from going up in flames. (Courtesy author Karen Hanning.)

Orla and Patrick O'Malley Daly, a brother-and-sister team, wish their customers "cead mile failte" from the Irish Castle on the corner of Geary and Shannon Streets. They purchased the business in 2004 from Hanna Hats, a woman who had grown up with their mother in Donegal. (Courtesy O'Malley and Daly families.)

Burton Kendall and son Sam are descendants of the woman who built this house on Market Street. Carmel, the wife of Tom Fallon, lived in San Jose until she divorced and then brought her children to her hometown to live. After the 1906 earthquake, with the fire rapidly advancing, Carmel refused to surrender her home, and mobilized her servants with water from her well. She so inspired people that the fire was stopped shortly after her residence was saved. (Courtesy Kendall family.)

Maureen Kavan from Kerry has owned Irish Delight in the West Portal neighborhood for 20 years, offering a great assortment of Irish goods including jewelry, children's T-shirts, Celtic DVDs, a variety of teas and food items, and Belleek china. (Courtesy author Karen Hanning.)

Located in the quaint West Portal neighborhood are Joxer Daly's Irish Pub, a fairly recent addition, and one of four Dubliner Pubs, a longtime establishment. A proper Irish breakfast, complete with soda bread, can also be found in West Portal at the homey Village Grill restaurant down the street. (Courtesy author Karen Hanning.)

This 2003 poster from an Irish film festival held in connection with the Irish studies program at New College publicizes a rare movie that told the story of Jewish people in Ireland who were involved with gun running during the Irish War of Independence, smuggling Jews into Palestine during World War II, and helping to found the independent states of Ireland and Israel. (Courtesy author John Garvey.)

Consul General of Ireland Donal Denham
Irish Arts Foundation
Irish Literary and Historical Society
Irish Studies Program, New College of California
and
United Irish Cultural Center Foundation
present

Ƨᴎᴀʟᴏᴍ IREʟᴀᴎᴅ

a documentary film about Ireland's remarkable, yet little known Jewish community

Shalom Ireland chronicles the history of Irish Jewry while celebrating the unique culture created by blending Irish and Jewish traditions. From gun running for the Irish Republican Army during Ireland's War of Independence to smuggling fellow Jews escaping from the Holocaust into Palestine, *Shalom Ireland* tells the untold story of how Irish Jews participated in the creation and development of both Ireland and Israel.

Thursday, October 23
6:00pm – reception
7:00pm – screening
United Irish Cultural Center
2700 45th Ave. (at Sloat)

$10 per ticket
Proceeds will benefit distribution of the film.

To reserve tickets send a check to:
Share Productions
616 Manor Drive
Pacifica, CA 94044

For information call (415) 387-9615 or email vlapin@aol.com

Shalom Ireland is sponsored by the Film Arts Foundation. Funding is provided by the American Ireland Fund, Ammerman Foundation, Fleishhacker Foundation, David & Barbara B. Hirschhorn Foundation, Morris J. & Betty Kaplun Foundation, Pacific Pioneer Fund, Peninsula Community Foundation, Ira M. Resnick Foundation, Shelley & Donald Rubin Foundation, Robert Sillins Foundation, Allen & Ruth Ziegler Foundation and individual donors.

The Irish Arts Foundation sponsored several film festivals before deciding to concentrate mainly on music events. This postcard is a memento of a film festival in 2005 presented at Roxie Cinema. The foundation now collaborates with the Irish studies scholars at New College in their annual Crossroads Event, which presents music, lectures, and literary events during the week of St. Patrick's Day each year. (Courtesy Irish Arts Foundation.)

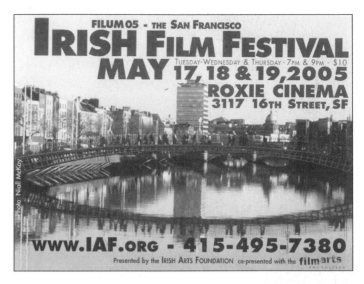

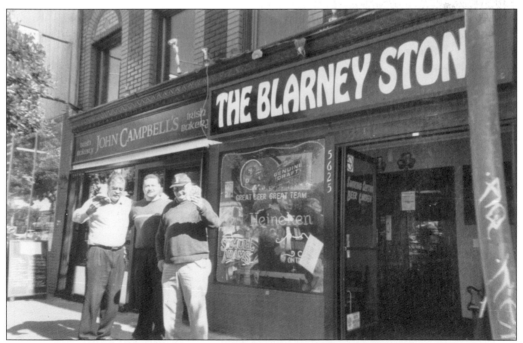

John Campbell's Irish Bakery, which opened in June 2007 on Geary Boulevard between Nineteenth and Twentieth Avenues, features potato and crusty brown breads and other hearty fare, including the traditional soda bread. Campbell, a master baker from Belfast with over 30 years of experience, fills the gap left by the recent demise of Star Bakery in the Mission District, which carried soda bread for over 70 years. (Courtesy author Karen Hanning.)

The United Irish Cultural Center began as a simple idea around a kitchen table and has become the heart of Irish activity on the West Coast. Its founders sought to honor the grand tradition of Irish culture in San Francisco by creating a suitable location to gather and continue building on the proud community spirit established by its forebears from the Emerald Isle. (Courtesy author John Garvey.)

Staffers Joan Riordan Minini (left) and Maureen Kelleher Lennon of the United Irish Cultural Center Library, pictured here by the library's door, stand ready to help patrons with research on the history and literature of Ireland and to provide suggestions for related local information. The library is open from 10:00 a.m. to 4:00 p.m. on weekdays. (Courtesy author Karen Hanning.)

Tom Sweeney began working at the historic Sir Francis Drake Hotel in 1977. With a love of the city and a vibrant personality, Sweeney is one of the most photographed figures in San Francisco, bedecked in his colorful Beefeater attire—a red jacket with gold braided embroidery, crimson knickers, and a black hat. A gin drink called a "Sweeneytini" is available at the hotel. (Courtesy Tom Sweeney.)

Jim Sweeney, the brother of doorman Tom Sweeney, designed the Irish San Francisco Giants baseball cap. In his formative years, Jim performed as the wildcat mascot at St. Ignatius College Preparatory athletic events. (Courtesy author John Garvey.)

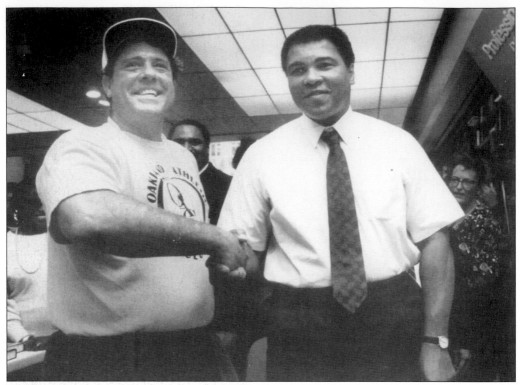

Muhammad Ali and San Francisco boxer Pat Barry shake hands at Stacey's bookstore. Ali's ancestry includes both Irish immigrants and freed blacks. An 1855 land survey of Ennis, a town in County Clare, Ireland, contains a reference to John Grady. Odessa Grady Clay, Ali's mother, was the great-granddaughter of the freed slave Tom Morehead and of John Grady of Ennis, whose son Abe had emigrated from Ireland to the United States. (Courtesy *San Francisco Chronicle* and Mary Barry.)

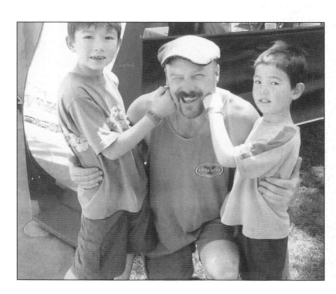

Irish boxer Pat Lawlor, the "Pride of the Sunset District," gets slugged by Christopher and Sean Garvey at the Concord Kid's Festival. Wilfred Benitez and Roberto Duran were two of the big names Lawlor defeated, and he lost to Terry Norris and Hector Camacho. In a poem, Lawlor wrote, "McGarvey was my manager, a good old Irish gent and all those big fights I had, he never took one red cent." (Courtesy author John Garvey.)

Bernie Ward is a popular liberal nighttime talk radio host on KGO 810 AM in his native San Francisco. A Roman Catholic and former priest of the Franciscan order, Ward hosts *Godtalk* on Sundays from 6:00 to 9:00 a.m., which doubles as a weekly on-air sermon for his Church of the Holy Donut congregation. (Courtesy Ward family and KGO.)

In a world rekindling its fascination with myth and magic, Sharon Knight feels right at home. The San Francisco–based Celtic songstress brings her own brand of enchantment to light with her collection of original and traditional songs. Sharon has long been inspired by the fierce and passionate spirit of the Celts. Sharon's "Song of the Sea" features lyrical tales of muses and sirens, magical spells, pirates, phoenixes, and otherworldly heroes. (Courtesy Sharon Knight.)

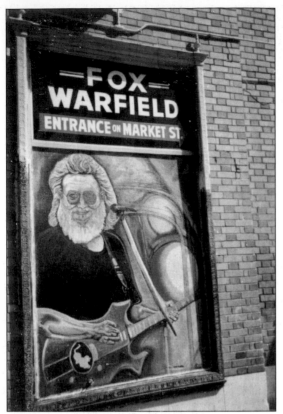

Jerry Garcia grew up in San Francisco's Excelsior District and dropped out of Balboa High School to enlist in the U.S. Army. He later became famous as the vocalist and lead guitarist of the rock band the Grateful Dead and was inducted into the Rock and Roll Hall of Fame in 1994. Garcia's mother, Ruth Marie Clifford, was a nurse of Swedish and Irish descent whose family immigrated to San Francisco during the Gold Rush. (Courtesy author John Garvey.)

Bill Bailey, a well-known labor leader in the 1930s and 1940s, came to San Francisco and settled here permanently after years of activism in New York, where he was born to Irish parents. He took part in preparations for the great San Francisco longshoremen's strike in 1934, which helped establish the eight-hour day and led to laws regulating wages and hours for dockworkers. (Photograph by Rich Gherharter, 1995; courtesy Blanche Beft.)

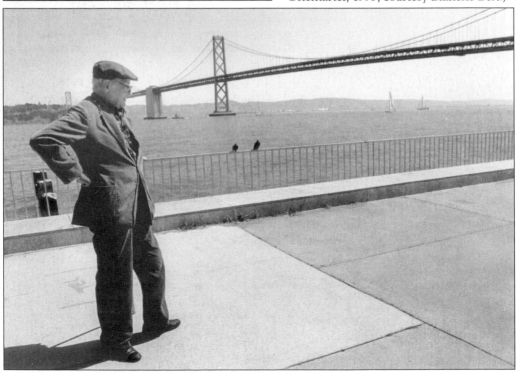

Betty Garvey was the mainstay of many activities for seniors in San Francisco, providing care, social opportunities, and transportation to many elderly. When she passed away in 2003, the senior center was named in her honor. Here two of her children, Claudia Curran and Paul Garvey, attend the celebration held to commemorate the opening of the Diamond Street Center in their mother's name. (Courtesy Mark Garvey.)

Edward Rutherfurd, a preeminent Dublin-based British novelist, is seen here in March 2007 at a public lecture at Stacey's bookstore on Market Street upon the release of *Ireland: Awakening*. His other works include *Russka*, a novel of Russia; *London*; *The Forest*, set in England's New Forest; and *The Princes of Ireland*. (Courtesy author John Garvey.)

Debbi Sivyer (left) and Mary Barry shagged baseballs as ball girls for Charlie O. Finley's Oakland Athletics. They wore green hot-pants with gold blouses, a colorful A's emblem on the side pockets, white belts with a green drawstring and white tassels, gold knee stockings, shiny white shoes, and green shoelaces. Debbi later started the well-known cookie company Mrs. Fields Cookies. (Courtesy Mary Barry.)

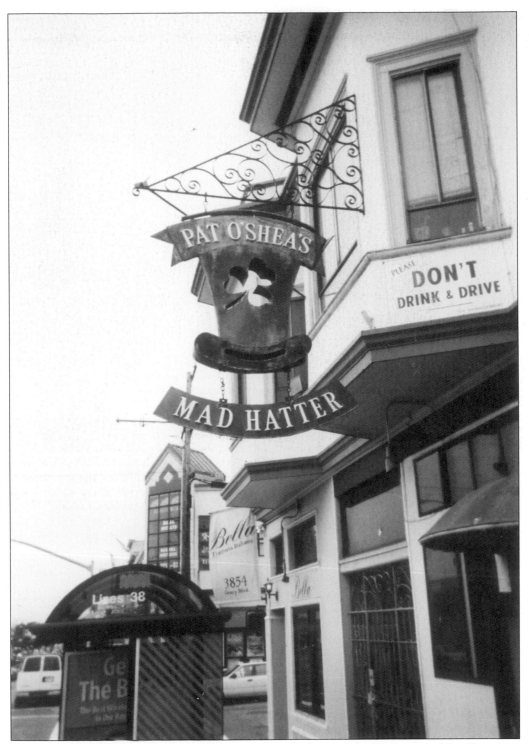

Pat O'Shea's Mad Hatter on Geary Street was a popular hangout for University of San Francisco students from "the Hilltop." Its motto was "We cheat tourists and drunks." (Courtesy author John Garvey.)

The Peter R. Maloney bascule drawbridge on Fourth Street is the companion bridge of the nearby Francis "Lefty" O'Doul drawbridge on Third Street. It was named for a police inspector who founded the defunct South of Market Boys organization. (Courtesy Ginny Maloney.)

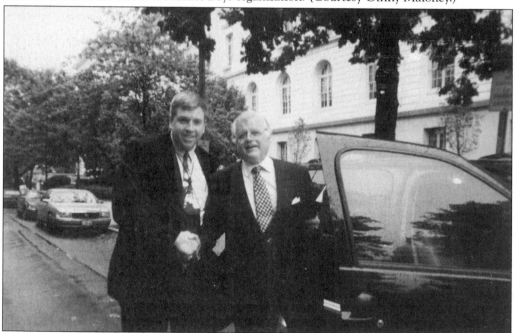

In this 1999 photograph, native San Franciscan and author John Garvey meets Sen. Edward "Ted" Kennedy outside of the Russell Senate Office Building in Washington, D.C. (Courtesy author John Garvey.)

On March 17, 1997, the Bank of Ireland (a bar and restaurant) in San Francisco formally changed its name to the Irish Bank. This change was the result of an amicable settlement with the Bank of Ireland in Dublin following a nine-month legal battle. Mayor Willie Brown presided over the name change for the pub, founded by Irishmen Chris Martin and Rory Connolly. (Courtesy author John Garvey.)

An operational Liberty ship docked at Fisherman's Wharf, the SS *Jeremiah O'Brien* served in World War II and traveled to Normandy for the 50th anniversary of D-Day, when Pres. Bill Clinton visited the ship. The ship was named after the Irish-born captain of the sloop *Unity*, who won the first naval battle of the American Revolution and captured the first armed British ship. (Courtesy author John Garvey.)

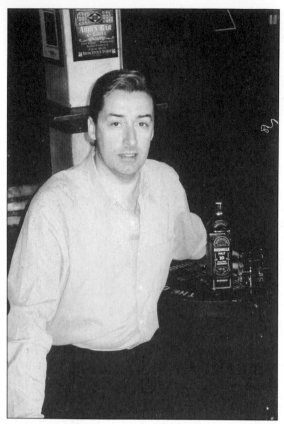

Eoin O'Neill opened O'Neill's Irish Pub by the AT&T ballpark in 2006. Another opened in 2007 in San Francisco's Ghirardelli Square. It is highlighted by a giant indoor mural featuring Sinéad O'Connor, Bono, JFK, Daniel Day-Lewis, Maureen O'Hara, and James Joyce sitting around a table drinking pints with O'Neill. (Courtesy Eoin O'Neill.)

Irish Hill was an area surrounding the industrial plants on Potrero Point where many Irish immigrant workers lived, as well as a number of families that took in boarders. Because the working day was long and transportation poor, workers preferred to live within walking distance of their jobs, despite the noise and pollution of heavy industry. (Courtesy Brendan Daly, Ireland's 32.)

Three McCarthys with ancestors from Cork, sons Chris and Matteo and father Brian, cruise through Golden Gate Park at the Bay to Breakers run in 1989. (Courtesy Brian McCarthy.)

Curtis Phelps and Maria Shriver are pictured at Stacey's bookstore on Market Street, as Shriver signs copies of her books. A veteran television news reporter and the first lady of California, Shriver expands on a speech she gave to her young friend Ally's graduating high school class in the book titled *Ten Things I Wish I'd Known Before I Went Out into the Real World*. (Courtesy author John Garvey.)

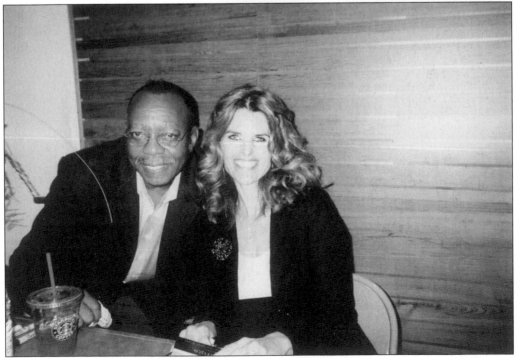

At Johnny Foley's Irish House on O'Farrell Street, visitors might swear they had been transported back to Dublin. The establishment was named for larger-than-life San Francisco character Johnny Foley, who was a newspaper business veteran, a sportsman, and a tenor. (Courtesy Mark David Ford.)

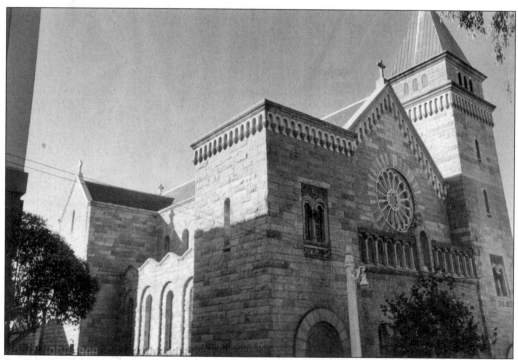

St. Brigid's Church, a parish that included many prominent Irish families when it was dedicated in 1864, was sold to the Academy of Art University in 2005. Its gray granite stone resembles that used on Irish coasts. Other sculptures and decorations are based on Irish manuscripts; its stained-glass windows were designed by Dublin firm Harry Clarke Studios; and the carpets were woven in Donegal by Dun Emir Guild. Over 18,000 people signed petitions to keep the church from being demolished, and the exterior of St. Brigid's became San Francisco Landmark No. 252 on October 24, 2006. (Courtesy author Karen Hanning.)

The 2002 funeral of Thomas J. Cahill, the longest serving SFPD police chief, included pallbearers, from left to right, Duggan mortuary staff person Diarmuid Philpott (SFPD), Warren Maloney (Maloney Security), Frank Jordan (former SFPD chief), Jack Cleary (SFPD inspector), Tony Ribera (former SFPD chief), and John Candido (SFPD patrol special). (Courtesy John Candido.)

Born and raised in San Francisco, Warren Maloney is a third-generation police officer who formed Maloney Security in 1976. He is also a Pacific Coast semipro alumnus, having played tackle on the South San Francisco Windbreakers from 1952 to 1954. The Windbreakers played against teams including the San Francisco Broncos, Petaluma Leghorns, Crockett Rockets, Fort Ord, Fleet City, and Santa Cruz Rangers. They once even played the NFL's 49ers. (Courtesy Ginny Maloney.)

Fr. Felix Cassidy, O.P., has been a Dominican for 53 years and serves at St. Dominic's Church on Bush Street. He attended St. Ignatius High School and the University of San Francisco, was a member of Boy Scouts Troop 14 and the Merchant Marines, and was a star tennis player. (Courtesy Judith Garvey and Fr. Joseph Sergott, O.P.)

The son of Margaret (Maggie) Shea and James Nolan, Lloyd Nolan was born and raised in San Francisco. He attended Santa Clara University and then began an acting career. He quickly rose to become a noted actor, and from 1940 to 1942, he appeared as the lead character in the "Michael Shayne" detective series. This gentleman, who made over 105 movies, passed away in 1985 at age 83. (Courtesy Gregory Zompolis.)

Irish Imports was a fixture on Geary Boulevard for about 50 years until its genial proprietor, Louis Roche, retired. Here he stands by the door, which was always open for conversation as well as to provide those little tastes of home like Irish sausages for the breakie. The smile on his face made people feel welcome and encouraged many a friendly chat over the years. (Courtesy Louis Roche.)

This is the plaque that hangs on the wall in the players' area of the San Francisco 49ers in honor of beloved coach Bobb McKittrick, who accumulated five Super Bowl rings. (Courtesy author John Garvey.)

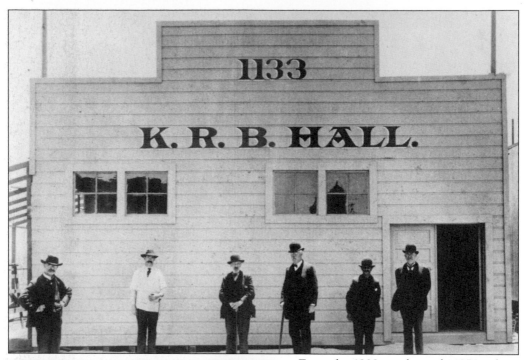

From the 1880s to the early 1970s, the place to go for young Irish and those of Irish descent was the Knights of the Red Branch (KRB) hall, which was located at 1133 Mission Street until after the 1906 earthquake and fire, when it was relocated to these temporary quarters. Pictured here are P. J. O'Reilly, T. J. O'Shay, John B. Walsh, Thomas Desmond, Johnny Campe, and William F. Coleman. (Courtesy Maureen Kelleher Lennon.)

The KRB hall was the venue for many dances and events. By the front entry of the hall, two who experienced those good times, retired SFPD deputy chief Diarmuid Philpott and Burlingame homemaker Maureen Kelleher Lennon, display a book by Anne O'Brien Hickey about this place of happy revelry, *The Ballroom of Romance.* (Courtesy author Karen Hanning.)

Bill Mitchell of the San Francisco Police Department served for a while in the horse patrol before moving on to the role of chief of police in the late 1940s. He had one son, Robert, who married but separated shortly after his son Bob was born. Bill died without knowing his grandson, who also became a cop in South San Francisco and is pictured below. Young Bob searched for his lost family connections and was given a copy of this picture. Bob decided that since he was carrying on his granddad's vocation, he should get his picture taken on a horse in his uniform. Here they are, finally together. (Courtesy Robert Mitchell family.)

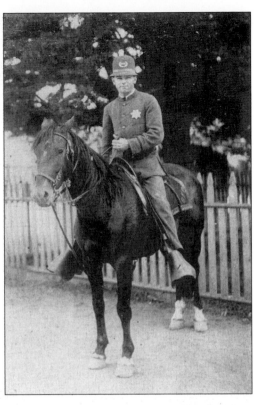

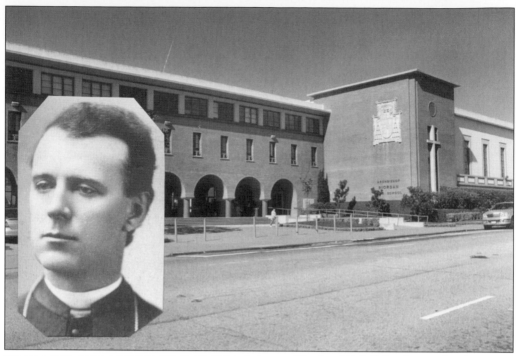

Riordan High School is run by the Marist order and named after Archbishop Patrick William Riordan. It is one of the three major Catholic high schools in San Francisco along with Sacred Heart and St. Ignatius College Preparatory. Though the schools have a friendly rivalry, they also celebrate a joint mass each year at St. Mary's Cathedral. (Courtesy author Karen Hanning.)

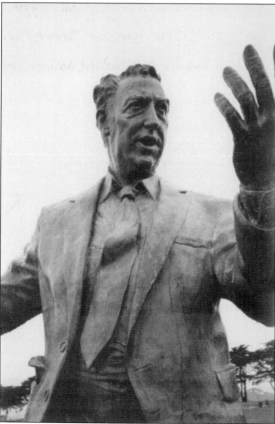

Phillip Burton, a veteran of World War II and Korea and a longtime congressman, was instrumental in the creation of the Golden Gate National Recreation Area. This bronze statue of Burton created by Wendy M. Ross is located at Fort Mason. His brother John L. Burton also served as a member of Congress. (Courtesy Rufus Watkins.)

BIBLIOGRAPHY

Burchell, Robert Arthur. *San Francisco Irish, 1848–1880.* Berkeley, CA: University of California Press, 1980.

Dillon, Richard H. *Iron Men: California's Industrial Pioneers, Peter, James, and Michael Donahue.* Point Richmond, CA: Candela Press, 1984.

Dowling, Patrick J. *California, the Irish Dream.* San Francisco, CA: Golden Gate Publishers, 1988.

———. *Irish Californians: Historic, Benevolent, Romantic.* San Francisco, CA: Scottwall Associates, 1998.

Murphy, Fr. Frank X. *Fighting Admiral: The Story of Dan Callahan.* New York: Vantage Press, Inc., 1954.

Hickey, Anne O'Brien. *Ballroom of Romance: The KRB Revisited: A Collection of Memoirs.* San Francisco, CA: California Publishing Company, 2000.

www.ilhssf.org

www.irishcentersf.org

www.sfstpatricksdayparade.com

ACROSS AMERICA, PEOPLE ARE DISCOVERING SOMETHING WONDERFUL. *THEIR HERITAGE.*

Arcadia Publishing is the leading local history publisher in the United States. With more than 4,000 titles in print and hundreds of new titles released every year, Arcadia has extensive specialized experience chronicling the history of communities and celebrating America's hidden stories, bringing to life the people, places, and events from the past. To discover the history of other communities across the nation, please visit:

www.arcadiapublishing.com

Customized search tools allow you to find regional history books about the town where you grew up, the cities where your friends and family live, the town where your parents met, or even that retirement spot you've been dreaming about.

MAP SEARCH